A FIELD
GUIDE FOR
FEMALE
INTERROGATORS

A FIELD GUIDE FOR FEMALE INTERROGATORS

COCO FUSCO

Seven Stories Press
New York / London / Melbourne / Toronto

A Seven Stories Press First Edition

Seven Stories Press
140 Watts Street
New York, NY 10013
www.sevenstories.com

In Canada: Publishers Group Canada, 559 College Street, Suite 402, Toronto, ON M6G 1A9

In the UK: Turnaround Publisher Services Ltd., Unit 3, Olympia Trading Estate, Coburg Road, Wood Green, London N22 6TZ

In Australia: Palgrave Macmillan, 15–19 Claremont Street, South Yarra, VIC 3141

College professors may order examination copies of Seven Stories Press titles for a free six-month trial period. To order, visit www.sevenstories.com/textbook or send a fax on school letterhead to (212) 226-1411.

Book and cover design by Loid Der
Illustrations by Dan Turner

Library of Congress Cataloging-in-Publication Data

[Fusco, Coco.
 A field guide for female interrogators / Coco Fusco.
 p. cm.
 ISBN 978-1-58322-780-0 (pbk.)
 1. Women--United States. 2. Military interrogation--United States. 3. Women--Sexual behavior. 4. Abu Ghraib Prison. 5. Women and war--United States. 6. Iraq War, 2003---Prisoners and prisons, American. 7. Women soldiers. I. Title.
 HQ1426.F887 2008
 956.7044'38--dc22
 2008005833

Printed in Canada

9 8 7 6 5 4 3 2 1

CONTENTS

INVASION OF SPACE BY A FEMALE

TORTURE: THE FEMININE TOUCH

Dear Virginia,

I have thought of you nearly every day since the war be-
gan. Obviously, I am not the only one—many feminists have
turned to you to refine their thoughts on war and its effects
on those who do not fight. But I also feel a little guilty about
turning your best known title[1] inside out by using it for my own
performance about the dark side of advancing women's rights
through warfare.[2] Your atelier becomes my torture chamber.
The comparison was intended to shock anyone who clings
to outdated ideas about women's relationship to power. Even
those without such preconceptions have looked askance
when I walk on stage in fatigues and combat boots and ex-
pound on women's "advancement" through war. Some say
I misunderstand women in uniform, while others say I mis-
understand war. Still others say my concerns are trivial given
that Iraq is in ruins and thousands of lives are being cynically
sacrificed to safeguard corporate profits. Should I preempt
my detractors and belittle my preoccupations by saying that
because I'm an American woman, I must be so self-involved

that I can only fixate on how war affects me?

That's not what I really think. Though much has changed since your time, women in the public eye are still expected to answer existential questions as women and for women. Some pretend that is no longer the case, but their willfulness doesn't eliminate a history that governs the experience of the majority. The wars that my country is waging in Iraq and Afghanistan feature a notable array of American women in uniform who have come to be known as villains, heroines, and victims of this conflict. When their actions are discussed, their gender is rarely ignored. And when I learned that their actions included torture of a sexual nature, I couldn't ignore them. Unlike you, I'm resigned to the persistence of war; but I won't accept torture as a legitimate component.

My personal history predisposed me to distrust war and all things military. I grew up during the Vietnam War era, embracing the anti-war sentiments that prevailed among the affluent and educated New Yorkers who surrounded me. I came of age at a time when feminists were resolutely anti-military, and my choice of art as a profession guaranteed me the company of every anti-establishment type. I lost a brother who joined the Special Forces and was killed in a covert mission in the 1980s, and then I watched the military do every-

thing possible to hide the circumstances of his death. Though I've joined many protests against unjust wars in my life, I'm sure there was a part of me that believed for most of my life that women were not really responsible for the battles that destroyed so many lives because we didn't fight in them. Now I find that myself transfixed by the women who are waging war in my name, sensing that their presence compels me to scrutinize my own misgivings and misconceptions about femininity and power.

You would be quick to point out that artists, being neither pundits nor politicians, are not obliged or even expected to respond to every aspect of a phenomenon as complicated and wrenching as war. On the contrary, our methods are better suited to explorations of its intangible and symbolic dimensions. Wars don't just happen on the ground; they take place in our minds, coercing us to believe in the necessity of what we might otherwise reject as excessive. In the past, even artists in this country who generally avoided other political concerns have felt moved to take on war as a subject, treating it for the most part as a tragedy. As the scale and means of destruction in war has escalated throughout the previous century, so has the chorus of artists' voices risen against it. What irks me now is that so few artists have chosen to respond this

time; it seems to be part of a general reluctance on the part of the public to express anything more than tepid ambivalence about the war or our declared enemies.

Yes, there have been demonstrations, but their scale is tiny compared to those of the Vietnam War era, and their "protest is patriotic, and we love the troops too" tone sounds conciliatory to me. The melodramatic tales about the victimization of our armed forces that circulate in pop culture substitute for a serious criticism outside the world of "experts" of how or why we fight. No matter how many public officials declare the invasion and occupation of Iraq misguided and mismanaged, and no matter how much outrage is expressed by human rights advocates about widespread violations of international conventions governing wartime conduct, the rest of us appear to be unconcerned with the ethical issues arising from American actions in the current conflict. That the state would not only condone but actively seek to legalize torture as a necessary means to combat terrorism doesn't generate a widespread public outcry—on the contrary, torture is seductive to us when superhero law enforcers use it effectively to save America from terrorism on prime-time TV. Even Supreme Court Justice Antonin Scalia invoked Jack Bauer, the protagonist of Fox TV's *24*, at a public event to defend the use

of torture—without irony.[3] On the other hand, star-studded films that depict the abuse of detainees and the rape and murder of civilians by US agents flop at the box office.[4]

One of the slickest and scariest elements of the current war machine is the effectiveness of the strategies used to distance most of us from it physically and psychologically. In an America with few tangible wartime hardships for civilians other than the rising price of gasoline, where 98 percent of the population doesn't engage in battle and where the president enjoins us to thwart terrorism by shopping, who really feels that we are drawn into the war? When the War on Terror was declared six years ago, I was overwhelmed by a sense of dread about the tidal wave of political changes that swept through the world as well as the US government's sophisticated means of suppressing the human cost of conflict. The explosion of patriotic fervor after 9/11—the televised concerts from Washington DC just after the attack that were such obvious, cryptofascistic rallying cries for war; the knee-jerk embrace of racial profiling of Arabs just after the practice had been publicly acknowledged as wrong and harmful to other minorities; the lumpen entrepreneurs on street corners making a fast buck peddling American flags; the obsequious stickers that soon appeared on cabs and gas station windows that said "Proud

to be Muslim and American"—all made me feel as though I had woken up inside a nightmarish cross between the Cold War and the Crusades.

The energy of the massive and global protests before the invasion melted into passive acceptance of the occupation within months. Vituperative attacks in the media on those intellectuals who dared to question the government's approach to Islamic fundamentalism made me self-conscious about speaking my mind in my own classroom. Though the restrictions on civil liberties ushered in by the Patriot Act bothered me, I became more distraught as time went on by my discussions about the war with students who claimed they were being misled by the government and the media, but lacked of the sense of urgency that might catalyze an active response. Not even the attempts by pro-military interest groups to restore officer training programs at the elite colleges that had banned them in the 1970s galvanized student efforts to oppose the militarization of campus life. The increasingly elaborate means of diminishing opportunities to experience empathy, fear, or pain, made it possible to keep the war at a comfortable distance. Disturbed by all this (and somewhat confounded by the war myself), I began to look back to how other artists had responded to previous wars as I tried to fig-

ure out what to think, what to write, and what to do.

Even though you didn't fight, Virginia, the thought of war consumed you. That is hardly surprising, considering that your entire adult life was overshadowed by two world wars in which new forms of technology made mass killing more efficient and impersonal than ever before. The capacity of so-called civilization to destroy itself trumped all other concerns, even for an aesthete like you, and compelled you to respond creatively and politically. You wrote your most memorable tales are about the reverberations of war in the minds of those far from the battlefield. As WWII closed in, you joined anti-fascist societies, and then in true Bloomsbury fashion, complained in print about the futility of societies. You procured lethal quantities of morphine that you were supposed to ingest with your husband if the Nazis invaded Britain and began rounding up Jews, but ultimately you drowned you yourself on your own.

You lost a nephew in the Spanish Civil War. I would imagine that this personal tragedy sensitized you more than ever to the images you received of that war's casualties. Photos of dead civilians in Spain frame your essay about whether and how women could involve themselves in preventing war.[5] It wasn't the piece of writing for which you would be most

remembered or revered. When I look at it now, much of it strikes me as shrill and quaint, even though I envy how much easier it was in your lifetime to make moral judgments about civilization and violence, good and evil, and the differences between the sexes. Who could blame you for thinking, in the mid-1930s, that fighting was "men's habit," or that warfare was considered an "outlet for manly qualities"? You contemplated war at a time when the lines were drawn quite clearly between men who had all the power and made decisions and fought wars, and women whose professional, economic, and intellectual aspirations were thwarted by their exclusion from public life and restriction to the private sphere.

Nonetheless, it seems to me that you vacillated in your argument. On the one hand, you suggested that although women wield little influence on the matter of war due to their limited access to power (the wives of powerful men excepted), they might be less inclined to favor it since warmongering is not in their history or their nature. On the other hand, you noted that women jumped to provide support for the troops during WWI as nurses and cooks because they were desperate to get out of the house. War not only offered them the opportunity to escape domestic drudgery but also gave them the opportunity to integrate themselves into a political project of

world domination that they perhaps unconsciously wanted to be part of. To prevent war, then, you maintained that women, however marginal their economic or political status might be, would have to actively resist by refusing to provide support for it. If they failed to do so, they would be subsumed by the machinery of death and destruction on the one hand, and "prostituted culture" and "intellectual slavery" on the other.

That was hardly an arbitrary choice of words. To describe how war instrumentalized immaterial elements of social being, you chose to imagine culture as a sexually exploited, probably female person. You equated the curtailment of mental activity in war with the deprivation of civil liberties that in your time applied to peoples living in parts of the world your country had colonized. War became the evil pimp and illegitimate master, while society became a terrorized subaltern. War was not just about political domination through physical violence leading to death, but about the exploitation of bodies and minds for financial gain, sexual power, and the censure of our unique capacity as human beings to engage in abstract thought. As a performer, I understand you to be saying that what makes war terrible is not just that it can kill us, but that it forces us to perform against ourselves—against our will, against our interests, against our values.

Your encounter with photographs of war forced such a visceral reaction upon you that you wrote as if compelled against your will, expressing this ambivalence through your textual references to the three years it took you to finally answer the question of how women could prevent war. Your fascination, shock, and skepticism regarding the photographs identifies you as a member of a society whose world views had only recently begun to be shaped by encounters with modern media. You sensed that the mind-wrenching pain of war together with the immediacy of the photographic image would eventually dwarf the power of words. That fear of the force of images speaks to me when you write that photographs of war victims is simply "a crude statement of fact that speaks to the eye."[6] Before I consider what it means to organize your argument around looking at pictures in which war is represented by civilian death and male power, let me return to your arguments about women and war.

So you, the fairy godmother of so many feminists, recognized that exclusion from power didn't necessarily make women immune to its seductive qualities or critical of the use of force. You could assume a righteous position in claiming that women couldn't be blamed for the existence of war but you stopped short of presuming that we could be counted

on as morally superior since we were ready to partake in it when it benefited us. That is hardly an outdated observation. Look at us now. There are more American women waging war these days than there are those who try to prevent it. While sexism persists, the categorical ban on entry to the professions that shaped your sense of women's experience is gone. Our country's high rate of unemployment, the demand for troops, and the absence of a draft have led to the unparalleled involvement of American women in the making of war. Our active duty armed forces have more women in them than ever before in history. And American women soldiers are closer than they have ever come to combat. It should come as no surprise then that the military would exploit their presence strategically and tactically.

The more access American women have to the exercise of political power and the use of deadly force in war, the more apparent it becomes that we aren't using it very differently from men. Furthermore, our status as minorities in public office and as relative newcomers in government and military duty, and the persistence of prejudice and sexual harassment to which we are subject, don't seem to deter us from advocating and partaking in violence against the enemy. Two thirds of the women in the US Congress voted in favor of invading

Iraq. Our first black female Secretary of State, Condoleezza Rice, lied about WMDs and allowed a legal loophole to protect Blackwater employees to escape recrimination for killing Iraqi civilians. The female Assistant Secretary of Defense and the Pentagon's spokesperson, Victoria Clark, created the notion of embedded media. The sole Congresswoman on the Judiciary Committee, Diane Feinstein, voted in favor of appointing an attorney general who wasn't sure if waterboarding is torture, while two others who were secretly informed of its use by the CIA five years ago raised no objections.

High ranking female intelligence officers in Iraq and Afghanistan authorized the use of coercive interrogation strategies—in other words, torture. Female interrogators sporting lipstick and sexy lingerie have figured prominently in both detainee and eyewitness accounts of sexualized excesses in interrogations. The now infamous prison abuse scandals at Abu Ghraib depicted in widely circulated photographs feature women whose sexualized humiliation of prisoners has come to symbolize the utter breakdown of any pretense the US may have once had to being a guardian of democratic values. Military intelligence and military policing—the two divisions of the armed forces that have come under the closest scrutiny in the wake of allegations of abuse—have a relatively high rate of

female involvement, since they are classified as non-combat duties. I know of only one woman from military intelligence who has made her misgivings about sexually humiliating prisoners public, and she was not an interrogator or a military policewoman whose training and routine contact with prisoners might inure her to actions that human rights experts would identify as egregious.

I don't think that the higher percentage of women contributed in a direct way to the abuse, but I do think that their presence has affected how scenarios have been enacted, starting with the selection of what images from Abu Ghraib were made public. Most of the pictures from Abu Ghraib have been kept from public view for fear of even stronger negative reactions at home and abroad; among them are scenes in which male soldiers are raping prisoners. On the other hand, the most infamous of those we have seen show women directing their looks at the camera. I keep asking myself if there might be some correlation between the relative lack of public outcry against the Bush administration's attempts to rationalize the use of torture and the prevailing images of its perpetrators as young and naive white women. Also known as "torture chicks," those women look much less intimidating than the oversized Special Forces commandos in black ninja suits

and masks who preside over interrogations in those notorious so-called black holes and secret prisons that are managed by the CIA.

Like most other feminists, what led me to consider what American women had to do with the war as we now know it were pictures from Abu Ghraib, not the trumped up tale of Jessica Lynch, the "war hero" from the early days of the invasion. Like you, Virginia, I was moved by images, but mine are not of the dead. My government does its best to keep photos of the dead, of our own dead and theirs, away from us. Nor can I restrict myself to those images that have been physically manifest, since so many of the atrocities of the war have only been described publicly with words. It was the images, both real and imagined, of what we were doing to the living and how we were doing it, that wouldn't leave my mind. In them, I saw ghosts of history, of times and places where dehumanization was routine and legal: the mob violence of the segregated South has frequently been invoked, but I was also reminded of French-occupied Algeria and the colonizer's use of torture against a nationalist insurgency. The cause of the current "enemy" is far less appealing, but that's not enough to convince me that we should accept the mental and physical destruction of helpless and sequestered human beings as part

of the rules of engagement. Susan Sontag, who led the fray in recalling your arguments about war and photographs, noted that those Abu Ghraib pictures were particularly disturbing because they created a place of pleasurable complicity for us as viewers, as lynching postcards once had.[7] The amateurish snapshots of smiling sadists in uniform taunting and bullying their victims had an insidiously intimate quality to them.

A frenzied competition over how to represent the military's treatment of "enemy combatants" ensued in the wake of the Abu Ghraib photographs' release. Official pictures of healthy looking detainees have proliferated in the press, but so have more disturbing "unofficial" pictures, some taken by soldiers, others by media critical of US policy and actions. The Department of Defense sought to counter the scandalous effect of soldiers' unofficial views with pictures of immaculate detention centers, detainees praying in their cages, being ceremoniously led on foot to and from interrogations rather than the more unsightly method of strapping and wheeling them there on tables. The orange jumpsuit and black hood became cultural icons of the global left; "detainee drag" has become a popular performance of anti-Americanism for anti-war demonstrators all over the world. I've used those jumpsuits, too.

It seems to me that my society succeeded in psychi-

cally suppressing the ethical crisis wrought by those pictures with tightly scripted responses that were repeated over and over. Horror was reserved for politicians, to make it seem that the state was not involved. Indignation went to the social critics but spread no further. Humanization of the perpetrators was fostered through soft journalism targeted at the general public. The popular media embraced the female soldiers who were court-marshaled, treating them as victims of their circumstances. The preoccupation with the details of Lynndie England's life—her backwardness, her poverty, her sad affair with Charles Graner, and their baby born out of wedlock— helped to deter public attention from the detainees who were the actual victims of torture. At the same time, the explosion of simulacra, of fake soldier snapshots and pornographic adaptations in the wake of the Abu Ghraib scandal, demonstrates that the prurient qualities of those images as images transcended moral circumspection. Not only was it disturbing to discover soldiers taking sordid war snapshots for their amusement, but the appetite for gruesome images calls forth the question of whether looking at war photographs these days has become a creepy and sadistic spectator sport for those of us far from the conflict. The military had exposed itself in pictures, so to speak, but viewers also began to expose

themselves. As I perused email responses to news stories about sexual abuse of detainees in which readers said they wished they could be "harassed" that way by female soldiers, I couldn't help wondering if escaping into erotic sadomasochism fantasies erodes the capacity for ethical concern for the effects of sexual torture. I know that is not a popular position among postmodern sex-positive progressives, but I admit I have thought about it frequently since Abu Ghraib entered public consciousness. I find myself having to remind audiences of the crucial factor of consent in the conversion of pain into pleasure. Detainees don't ask for what they get and don't know when it will stop. They don't get to say "No means no."

The perverse appetite for images of violence also made me think of the story I had once read about a man who did his military service during the Vietnam War as an archivist at the Department of Defense and never engaged in combat. Nevertheless, he suffered a mental breakdown from looking at scores of pictures of mutilated and defiled Vietnamese corpses, including some that featured heads with mouths stuffed with severed genitals. These images were brought back to his hometown by soldiers and passed around in secret.[8] One would hardly worry about that sort of danger to our sensibilities now. On the contrary, many of those who study

visual culture for a living worry aloud about the lack of visceral response to images of actual atrocities, wondering if we are desensitized because of sensory overload, because of the privilege of political indifference, or because violence severed from actual effects is so commonplace in movies and games. Sontag thought that those of us who don't experience horrific and overwhelming violence of war won't fully understand it by looking at photographs; at the same time, through her own effort to work through a history of attitudes towards images of war, she invites the rest of us to keep trying. While I agree with Sontag, there is more at stake. War is something more than the experience of it on the ground, and the factual and fictional representations of war do their work on us by coaxing us to accept, decry, or ignore it. If we give up all efforts to identify and set limits to uses of force that are excessive, unwanted, and unmerited, we essentially relinquish any agency with regard to politics, and acquiesce to authoritarian control of our lives or those of others.

Admittedly, when I saw those Abu Ghraib photos, I was surprised to find women soldiers in them. Shows you how naïve I was about women's involvement in the making of war. I was probably too comfortable with the assumption that women are always the victims of sexual torture in war, recalling the

stories of exiles who fled Latin American military regimes in the 1970s and the systematic use of rape by Serbian forces in the Bosnian conflict of the 1990s. While the media frenzy over the Abu Ghraib photographs focused on the question of the soldiers' culpability, I wanted to know how they got there, how many of them there were, who came up with the idea to do such things to prisoners and why. At first, I wasn't sure if it really mattered to me that some of the MP's in the photos were women. Soon thereafter, however, I started to notice that gender was key to the interpretation of the events depicted and to diverting public attention away from the pervasiveness of prisoner abuse by engendering public sympathy for the handful of underlings who bore the brunt of the punishment.

Then came the revelations that the Pentagon had approved sexual tactics in interrogations.[9] Female interrogators were reported to be giving hand jobs and lap dances to prisoners at Guantánamo, and smearing them with fake menstrual blood. That made it clear to me that while the Abu Ghraib prison abuse scandal was being treated as an anomaly, the use of women as sexual aggressors was planned as part of a program. As the government's rationalizations of torture grew more twisted, and popular cultural renderings became increasingly celebratory, I started wondering what we were be-

ing encouraged to see torture as, what aspects of it were being avoided, and what the images of women had to do with it.

That's when I decided to take an extended trip into the fantasy world of military interrogation. I purposely chose to avoid focusing on the experiences of detainees; I didn't want to contribute to a common tendency among the opponents of the war to suppress acknowledgment of ourselves as Americans by identifying exclusively with the victims of the violence carried out in our name. To make sense of the ways that torture was being normalized in my own culture, I thought I needed to get a sense of how American interrogators were trained to see what they do as necessary and just. My sense was that they learn through the discipline of military training, while the rest of us are coaxed to acceptance through the pleasures of viewing. My goal was to create a character—an implacable female interrogator who could speak about the issues and events that had unnerved me. She's a bit like your version of Shakespeare's sister, but she actually gets the chance to show her stuff. She believes she can discern a prisoner's weakness in seconds, reduce him to a quivering heap, or lie and give him false hopes of release in the name of freedom, and then step into a mess hall for a burger and crack a joke. If called upon to do so, she'll whip

off her jacket, shake her boobs at her prisoner, and then exit to fill out forms while he wrestles with his sense of shame. She is the kind of person who sees her own internalization of the military's worldview and her success within its structure as feminist gains. Shudder as I may, there are more than a few living and breathing women out there who see things her way. My character is a fiction but the things she talks about are excruciatingly real. What I would learn is that every interrogator assumes a fictional persona when working, even though the substance of their "conversations" with prisoners and the stakes in the exchanges are very real.

While I have found very few public documents that deal specifically with female interrogators, when it comes to interrogation, there's plenty to work with. Human Intelligence Gathering, as it is called in military parlance, has been one of the hottest topics in entertainment and publishing since the War on Terror began. Watching old movies about POWs and new made-for-TV homages to special agents became my background research into a cultural imagination; however inaccurate the representations of interrogations are in the media, they still shape the public's sense of what it is. I poured over detainee testimonies and human rights reports, devoured soldier memoirs, and interviewed military person-

nel. I read CIA manuals and Justice Department memos. In short, I tried to learn their language. And then, still hungry for a closer look at how that language is spoken, I took a group of young women with me to study with retired Army interrogators who offer courses on interrogation and prisoner of war resistance tactics to civilians. Ostensibly I was there to learn a skill from the teachers, but watching them in action allowed me to understand how they see the world and the enemies who sit across from them as they work.

This flight into simacrulum didn't provide me an escape from war, Virginia. On the contrary, it has plunged me into its mental landscape. Making up a character and taking her on the road, I've been able to talk publicly about subjects that too many "sisters in struggle" are afraid of and run away from. I asked myself—and provoked others to ask themselves—how does one become an interrogator who can do these things? Who are these female interrogators? What exactly are they doing? And why?

NOW YOU SEE IT, NOW YOU DON'T

You may be fuming by now, Virginia, because I have not made an effort to catalogue all the obstacles that female soldiers face in what remains a nasty line of work in an excessively masculine and misogynist milieu. Quantifying adversity, however significant a feminist exercise, is insufficient means for understanding women's relationship to power in a neo-conservative state. Focusing exclusively on women's experience of hardship may actually give the military more ways to obfuscate its excesses toward others. I'm not trying to suggest that sexual aggression as a form of torture is the only thing that should concern those who decide to think seriously about the war. But it would be unwise to overlook it. Torture dominates the discursive field of this war as a public image crisis for the US military, as a practice to be rationalized through the verbal gymnastics of legal theorists, and as the paradigm through which the rights we grant our enemies are formulated and the righteousness of our own use of force is measured. The gendered and sexualized character of most publicized abuses gives its current incarnation a particularly sensationalist character. I doubt the practice of torture by agents of a presumably democratic state has ever been so visible or that that

feminine visibility has contributed to its normalization.

How did it happen that torture took center stage? It wasn't simply the result of an unanticipated scandal. The more information comes to light, the clearer it becomes that torture is an integral part of the overzealous reaction to an unanticipated insurgency and an unfamiliar enemy. An apparent lack of information about our opponents and their motives led to indiscriminate round-ups and long-term detentions, turning military prisons into a central theater of operations. Most military interrogators who have gone public insist that they can do their jobs without crossing the line, and that they are taught not to torture. At the same time, they all acknowledge that the particular conditions in this war have created a slippery slope. Psychology experts have enumerated the factors that increase the potential for torture's occurrence at the hands of American soldiers: a hierarchical culture demanding obedience to authority, the isolation and dislocation of soldiers, insufficient supervision, frustration, fear, and the pressure to produce quick results. Whistleblowers and critical commentators have pointed to the confusion about permissible tactics generated by frequent alterations of policy and its interpretation along the chain of command. They have also noted the irregularity of putting military police under the

control of military interrogators, a scheme devised by hard-liner General Geoffrey D. Miller at Abu Ghraib to transform the physical management of prisoners into punitive aggression that would induce cooperation in the interrogation booth. Disgruntled soldiers suggest that their working in proximity to the CIA and private contractors who are not bound by the same restrictions led to coercive methods spreading virally into the military's repertoire.[10]

Much speculation has taken place over the last three years about whether the intelligence community developed these sexual tactics because of cultural stereotypes about Muslims and Arabs that have achieved the status of truisms in military circles. Veterans of military intelligence who received training in the early stages of the war have noted that they received lectures on the so-called "Arab mind," in which it was argued that when it comes to sexuality, Muslim men are more vulnerable than Westerners.[11] Outdated anthropological arguments become the basis for the development of tactics that manifest themselves in the roles interrogators assume for themselves and impose on their sources. Male interrogators tend to degrade male prisoners by forcing them to perform homoerotic acts presumed to be humiliating, threatening and insulting them, but stop short of performing these acts them-

selves. On the other hand, women interrogators use sexual insults, force them to engage in humiliating acts, and also perform sexually for them. Their most infamous antics include gyrating half-clothed atop seated prisoners and smearing them with fake menstrual blood in an attempt to break them by invoking a cultural taboo. Apparently, when male interrogators perform sex acts on non-consenting subjects it is understood as sexual assault, but when women do it, it can be authorized as invasion of space.

Torture is not a new element of war. Interrogation has invariably been crucial to military efforts to thwart insurgencies, and rare are the instances in which information is obtained from captured enemies without some degree of physical or psychological violence. Nevertheless, the presumed moral superiority of democratic governance and modern warfare is based on the criminalization of the indiscriminate killing of non-combatants and of torture. Our public discourse of the last fifty years has defined torture as an antiquated practice of non-democratic regimes that is antithetical to our values and that endangers our own troops. At the same time our political goals on the world stage continue to make torture expedient when accepted means within a democracy are deemed to be too expensive or contrary to US interests. The US has

maintained a conveniently duplicitous attitude and approach toward torture: we tell ourselves that we don't do it, and at the same time we clandestinely support and work with others who do. We deny our involvement, outsource most of the nasty labor to proxies abroad, and invest locally in the development of psychological coercion methods that leave fewer visible scars. That is the disingenuous hide and seek game we play with torture, pretending that we don't do it if we can't see it. Now that our involvement has become visible, we continue the ruse by trying to call it something else, or saying we are not sure what it is. The hairsplitting in legal discussions of what might or might not be torture would certainly strike you as being as utterly perverse, Virginia, as it does me: how is the actual filling of the lungs with water in waterboarding only a "simulation of drowning"? By what insidious logic can it be that threats of death and prolonged isolation are not torture because the psychological pain induced cannot be equated with organ failure?

When I speak of the current debates in the US about torture in countries where that outsourcing has taken place, I am invariably reminded by audiences that only fools believe that Americans do not engage in torture. They've seen it and lived with it up close; it's not just a tidbit from a high school

history lesson or a cop show rerun, and when dolled up versions show up in porn or advertising, people complain—loudly. For those in proximity to the practice, torture is experienced as a real life political drama that ritualizes the violence of occupation through excruciating compulsory performances of mental and bodily submission. We, on the other hand, are experiencing torture in this war as a spectacle from a faraway place. That spectacle has a peculiar relationship to it own indexical representation. By this I mean that even though the idea of torture dominates the media sphere and public consciousness, we are compelled to imagine the full range of what it is through personal and collective fictions, because most of us don't get to see much of the real thing. Despite the widespread circulation of the Abu Ghraib photographs that depict military police abuse of prisoners, the public does not see most visual documentation of proceedings in interrogation rooms in military prisons. Over the past four years we have been informed that such images have been classified, destroyed, lost, or censored in the interests of national security—but who complains besides lawyers who want to make a war crimes case against the state? Congressional hearings and human rights investigations feature protracted semantic struggles to determine, in the absence of pictures, what hap-

pens in those stark rooms. That dearth of publicly available documentary images of military interrogations contributes to the inflation of value of testimonials and "expert" speculation.

Sexual harassment performed by female interrogators is not something that the American public has actually seen. Several months after release of the Abu Ghraib photographs, a story appeared in the news about a former Army translator whose eyewitness accounts of interrogations at Guantánamo featured a female interrogator who had smeared fake menstrual blood on a detainee.[12] Shortly thereafter, the Pentagon publicly confirmed that "sexual tactics" had been used on detainees. Subsequent detainee testimony from Guantánamo and Abu Ghraib contained numerous references to women in the prisons, sometimes described as prostitutes, who sexually taunt them. Other stories have surfaced from time to time about male interrogators' use of sexual tactics as well. None of these reports has sparked the same degree of controversy, probably due to the absence of photographs.

For every revelation of excess by a remorseful perpetrator, angry prisoner, or troubled witness, there are ad hominem attacks on whistleblowers and "untrustworthy Muslims," defensive rebuttals from other soldiers, and byzantine

rationalizations from the military. On top of this, the White House continues to issue flat out denials: we don't torture, no matter how much evidence there is to the contrary. I don't know at this point what is more sickening—the photos from Abu Ghraib, the use of denial as a tactic of persuasion, or the ways that our military codes can actually be construed to permit much of what would "shock the conscience" of many a civilian and soldier. What else should I feel when I read a Department of Defense memo from a staff judge advocate (who happens to be female) recommending that military members who use death threats or waterboarding against detainees should seek prior permission or immunity since they might be construed as violations of the Uniform Military Code of Justice?[13] The government has turned legal debates about torture into exercises in semantic subterfuge so that the practice can continue take place while the decision makers deliberate duplicitously about what it "really" is.

Whereas obfuscation seems to be the rule for the policy makers, the fictional visualizations of local and global policing that pervade tele-visual space follow a much clearer trajectory, assuaging fears about unpredictable people with interrogations that are swift, violent and effective. Watch *Sleeper Cell*, *24*, *The Unit*, or even the abundant cop show reruns

that fill our airwaves. Suspects are routinely beaten, lied to, and threatened with death and violence to family members, and lo and behold, the needed data emerges. Torture is thus normalized in popular culture as an effective means of eliminating the unknown. Criminals, whether they are motivated by politics or driven by psychopathology, all succumb to the male protagonist superheroes of contemporary terror-inspired fantasies about world domination. Could it be that in our hearts we want the full protection offered by authoritarian rule, while in our minds we seek to deny our acceptance of its means? Could that be why fresh-faced young women hovering over brutalized bodies symbolize the real American drama surrounding the practice of "torture lite?" They hardly seem to be capable of masterminding anything like an illegal covert program functioning on a global scale.

Singling out the hapless "torture chicks" from the rest of the soldiers who authorized and committed abuse is as an expedient distortion of the mistreatment of detainees and prisoners. It has helped the military to make the case in early stages of the Abu Ghraib scandal that abuse was the result of personal flaws in a few low-ranking soldiers rather than the wrongdoing all the way up the chain of the command. It has diverted attention away from the influence of a culture of

sexual humiliation that is integral to military social life. The female soldiers who were court marshaled were not only not alone or in the majority, but the media's honing in on them with greater intensity made torture at the hands of the US military seem a lot less frightening. Yes, Lynndie England had a guy on a leash, but in the picture she wasn't choking him by pulling it. Yes, the prisoner in the picture with Sabrina Harman is dead, but her smiling presence in the shot does not indicate that she killed him, only that she was responding inappropriately to his death.

Here's how the implicit argument goes: How bad can torture really be if performed by a member of the "weaker sex?" Doesn't torture require something more aggressive than insults and humiliating acts? Aren't most women in the military struggling to survive and get ahead in an overwhelmingly masculine environment where they are frequently subject to unwanted sexual advances? Can poor, uneducated women who themselves are victims of their boyfriends in addition to being tools of an authoritarian power structure like the military be blamed for violating human rights as part of their job? If torture involves women doing things to men of a sexual nature, which has been the case in numerous interrogations in Guantánamo, Iraq and Afghanistan, can it even be

called torture?

Military investigators have determined that some female interrogators' sexual taunts fall under the authorized tactic called "futility," meaning that they contribute to convincing a prisoner that all his efforts to resist are doomed to fail. Other actions were found to fall under permissible "mild non-injurious physical touching." More extreme actions such as the smearing of fake menstrual blood were deemed excessive, but a crucial rationalization was added that absolves the chain of command.[14] Those actions were also characterized as retaliatory, enabling the military to blame the individual who did not seek prior authorization, which, it is implied, she would not have received. Nonetheless, no formal disciplinary action was taken against the interrogator, who also refused to be interviewed. The ostensible reason given was that too much time had passed and the interrogator was no longer in the armed forces. However, in not taking action, the military implicitly invites others to continue the practice as long as they can keep it under wraps.

While the state and the media may use cultural perceptions of women to temper the image of Americans as torturers, their presence also serves a larger agenda. That agenda is emblematic of the ways that the Right has marshaled the dis-

courses of identity politics in the twenty-first century to serve conservative causes. As the number of women in the US military grows, the ways to capitalize on them by transforming their particular assets into weapons increase. Cultural perceptions of women can be used strategically to humanize the current US military occupation of Iraq, in that women are assumed to be less threatening. Women's presence also creates the impression that American institutions engaging in domination are actually democratic, since they appear to practice gender equity. On the other hand, specific use of women as women in military interrogations to provoke male anxiety actually corresponds to an authorized tactic called "Invasion of Space by a Female." The existence of this standardized term is testimony in itself of the state's rationalization of its exploitation of femininity. Despite all the handwringing in the media about why some military police at Abu Ghraib could not prevent themselves from brutalizing prisoners, little attention has been given to the implications of formulating strategies that turn female sexual exhibitionism into a weapon.

There are many different ways that women function as a mitigating and punitive force in the military carceral scenario. The testimony of several detainees suggests that they are frequently confused by the presence of women soldiers

in military prisons. Sometimes they assume that the women are sex workers who are brought there to provide services to Americans, or simply to sexually torture them. Testimony also indicates that some prisoners are particularly sensitive to the effects of sexual taunting and insults by women soldiers and that this vulnerability is exploited.[15] But there are also plenty of ways that the routine duties of military police can be experienced as humiliation by prisoners: they control prisoners' movements, strip and search them, shave and shear them, and survey them as they bathe and relieve themselves. The interactions with MPs are disciplinary performances of subjection, and gender can easily be used to intensify the experience without it appearing to be intended or considered sanctionable. An account by one interrogator noted that female MPs have at times been assigned in order to soften the experience of adolescent detainees. On other occasions their presence is intended to irritate male prisoners who it is assumed will perceive it as an affront to their dignity.[16] That effect is not inevitable however: former detainee Moazzam Begg writes in his memoir that he developed a fairly amicable rapport with one military policewomen who guarded him.[17]

The level of gendered provocation rises when women soldiers are used in interrogation to coerce and delude pris-

oners by representing sexually charged cultural stereotypes of femininity. This includes using women as bait: one interrogator recounts, for example, how he created a scene designed to entice a young detainee into becoming a potential informant by allowing him to sit unshackled in front of a television playing an American movie with a blond female soldier.[18] The same interrogator maintained in his account of his experience supervising an intelligence team in Afghanistan in 2002 that women were best at assuming the roles of the "befuddled interrogator" or the compassionate solace-provider: in other words, the bimbo who can't do her job, or the sympathetic mom who wipes your tears.[19] He also sent a female interrogator out to question Afghan women after their male relatives were arrested, assuming she would be less threatening and that this would lead to a naturally favorable rapport.[20] One of my teachers in the interrogation course commented that female interrogators could leverage their gender and elicit confessions best by pretending not to be interrogators at all, posing instead as nurses or even girlfriends. These sorts of scenes can turn into the starting point for pointedly sexual aggression, but it appears that in many instances, the gendered exchanges have remained relatively controlled. Those who call for the use of women in this manner claim to believe

that the cultural particularities of Muslim prisoners will make them more sensitive to their presence. However, I would argue that it is equally likely that the decision to use women in this way is also informed by American perceptions of women. The personae described are recognizable types drawn from an American cultural context. The American military milieu is often characterized as hostile to women because of the prevailing tendency among the men to sexually objectify them: the roles women are asked to play in order to harass the prisoners correspond to sexist characterizations that are leveled at them by male soldiers in other contexts as forms of denigration.[21]

The tenor of the interactions between male prisoners and female soldiers changes when they are intended to destabilize prisoners by demeaning them. Several accounts by detainees mention that female soldiers humiliated them by looking at them when they were naked and hurling insults about the size of their genitals. This performance of "the castrating bitch" is described in Sergeant Kayla Williams' account of her contact with interrogators in Iraq. Though she herself was not an interrogator, she was called upon to help with interrogations at Mosul because she speaks Arabic and is female. The male interrogators on hand brought in a prisoner

and removed his clothes, and then instructed her to "mock his manhood," "ridicule his genitals," and "remind him that he is being humiliated in the presence of a blond American female."[22] While she felt uncomfortable with and unfit for the role she was asked to play, she found greater fault with the male interrogators who slapped and burned the prisoner in her presence. To Williams, their actions violated the Geneva Conventions, but apparently sexually humiliating words did not. As she details her own discomfort with what she was asked to do, she also speculates on what kind of training one would need to perform the role effectively, which suggests a degree of acceptance of the legitimacy of such actions.[23] Williams later met the female interrogator she had momentarily replaced and discovered that she defended the tactics as legitimate. For the most part, so have her superiors.

Up to now, there is only one publicly known instance of a female interrogator being sanctioned for tactics used on a prisoner. Stationed at Abu Ghraib in 2003, she was cited for forcing the man to walk through the prison hallways naked in order to humiliate him into cooperating.[24] According to many accounts, however, the level of sexual provocation of male prisoners by female soldiers reaches far greater heights. Womens' words and actions have been combined with cos-

tumes and make-up: tight shirts left unbuttoned, high heels, sexy lingerie, loose hair, and garish makeup have all been mentioned in detainee and eye witness accounts. The sexual language used is apparently not restricted to insults; several detainees have claimed they have been threatened with rape. Pictures of semi-naked women were hung around the neck of the alleged "twentieth hijacker" in an attempt to unnerve him.[25] Reports have circulated that female soldiers have fondled detainees' genitals, and that they have forced detainees to masturbate in front of them. Female interrogators have also been described as using many forms of sexually aggressive behavior in booths, ranging from touching themselves and removing their clothing, to touching the prisoners. Some of the provocateurs have worked in teams of two or three, all sexually harassing the same prisoner. All the actions are combined with sexual language to enhance effect: sometimes the language is accusatory and demeaning, other times it is designed to effect arousal. A Yemeni detainee claimed that when he refused to talk in an interrogation, a female interrogator was dispatched to his booth in a tight t-shirt; she asked him what his sexual needs were, showed off her breasts, and simply stated, "Are you going to talk, or are we going to do this for six hours?"[26] Another account from a detainee held at

Guantánamo affirmed that his interrogator combined sexual provocation with politically inflammatory statements, baring her breasts while reminding him that his attorneys were Jews and that "Jews have always betrayed Arabs."[27]

Key to all these deployments of female sexuality as a weapon is that they are planned. To me they are indicative of the state's instrumentalist attitude toward gender, sexuality and cultural difference. In other words, if the military is going to incorporate women, it is also going to capitalize on their particular assets and take advantage of permissive societal attitudes regarding sexual exhibitionism. The effort to gather information about another culture is turned into an opportunity for using gender and sex as punishment. The purported sexual freedom of American women becomes something with which to bludgeon imprisoned men from supposed less permissive cultures. The fact that reports of such activities have come from several military prisons makes it virtually impossible to dismiss individual instances as aberrations or the invention of an isolated eccentric. The most widely circulated theory that has emerged to explain why these tactics have been implemented—that intelligence experts latched onto outdated Orientalist views of Arab men as sexually vulnerable in the scramble to extract actionable intelligence as quickly as

possible—is supported by interrogator accounts of how lectures on the so-called "Arab mind" were integrated into their training once the insurgency began.[28] Military investigations into reports of such actions have either justified them when performed under the rubric of an authorized interrogation plan, or blamed individuals for supposedly failing to obtain authorization prior to execution of the acts. Like every other "coercive tactic" that has come under scrutiny through recent human rights investigations, female sexual aggression toward prisoners is not unequivocally condemnable by the military's own legal standards.

That may explain why female intelligence officers would authorize and accept orders to deploy sexuality as a weapon. It is not clearly understood as a infringement of military conduct, nor is it seen by the military as a violation of human rights if there are legitimate state interests. So a female agent of the state who sexually accosts prisoners to root out terrorism is just doing her job. For civilians accustomed to a certain degree of autonomy regarding their bodies, the idea that one could be ordered to behave sexually may seem to be beyond the call of duty, but soldiers have in theory already agreed to sacrifice their lives, so sexual aggression in the service of a greater cause may appear mild by comparison. In theory,

members of the military are entitled to question and refuse what they believe to be unjust orders. The question here would be how to define the injustice. Kayla Williams didn't find fault with the order; she found herself to be lacking in ability to perform. In other words, she personalized an ethical and legal issue and thus avoided confrontation regarding the legitimacy of the practice. From what I have been able to gather, it does not seem that this is an uncommon position among women in the military. When I asked a few young women who had served how they felt about being asked to use their sexuality as part of their patriotic duty, they seemed to have difficulty understanding the question, or perhaps they thought it was too sensitive to answer. Only one said it made her think of Playboy bunnies dancing for soldiers in the USO—a famous scene from *Apocalypse Now*.

I don't think the sole issue here is the way that the codes of conduct in war can be construed to justify unconscionable acts. It seems to me that our culture lacks a precise political vocabulary for understanding women as self-conscious perpetrators of sexual violence. We rely instead on moralistic language about virtue, privacy, and emotional vulnerability to define female sexuality, or on limited views that frame women's historical condition as victims. Since the

1970s, feminists have tried to undermine the repressive moralistic language by arguing that female sexual assertiveness should be understood as a form of freedom of expression. While I don't disagree with that position, the sexual torture dilemma is making its limitations glaringly apparent. Flaunting one's sexuality may indeed be a form of self-realization, but it doesn't happen in a vacuum, nor is the only context for its appearance democratic. The absence of consent from the recipient turns the display into an act of violence. And when this imposition has been rationalized as part of an interrogation strategy, the act ceases to be strictly a matter of personal responsibility. We don't like to look at ourselves that way. Our popular culture represents female violence as the product of irrationality—the spurned lover, the irate mother, the deranged survivor of abuse. So the picture of what we are becoming in war cannot be not clearly drawn.

The photos of prisoner abuse from Abu Ghraib that were made public are profoundly disturbing. The grainy snapshots document political performances of American-ness that both the state and the citizenry may seek to distance themselves from, but that were nevertheless carried out in our name. Whereas photographs of murdered civilians once stood for the injustices not only committed by Franco's forces

in Spain but also those of US troops in Vietnam, it is the images of American soldiers torturing helpless Iraqi prisoners that have come to stand for the illegitimacy of the occupation. We've tempered the implications of those pictures with explanations for the misconduct that enable us to condone the occurrences. According to officials who have seen the additional images that were censored from public view, the ones we saw represent the tip of the iceberg, and other abuses depicted include urolagnia, rape, and sodomy. But that is not what we see Charles Graner, Sabrina Harman, and Lynndie England doing. The ubiquity in the media of photos of them posing with Iraqi prisoners has helped to limit the understanding of sexual torture as a calculated practice. The absence of presiding authorities and the shocking gratuitousness of the violence make it difficult to determine who controlled the scenes, or even imagine that there would have been a director for this theater of cruelty. In that sense what the MPs are shown doing in those photographs is somewhat different from what has been described in numerous testimonies and investigative reports as the carefully orchestrated coercive sexual tactics that have been used in recent military interrogations.

The parade of sadism featured in the Abu Ghraib photographs has a riotous quality, exacerbated by the looks of

glee and upturned thumbs of the MPs. Regardless of who told the perpetrators to do what they were doing, their apparent excitement was probably intensified by the communal character of the brutality. Interrogators, on the other hand, are trained never to allow themselves to emotionally engage their sources since this would impair their ability to maintain control. The female MPs involved participate in the sexual humiliation of the prisoners, but not through exhibitionist display of their sexuality. Their non-sexual demeanor combined with the looks of complicity make them seem to be asking to be viewed as "one of the guys"; their performances are directed at other (male) soldiers rather than detainees. Their diminutive presence creates the impression that less harm occurred because women were involved. On the other hand, the female interrogators who sexually harass detainees manipulate male anxiety by enacting their submission to female power as a monstrous, if not grotesque, sexual experience. While human rights experts, lawyers, and cultural theorists are still arguing about whether the Muslims are indeed more culturally sensitive to sexual harassment from women, there is testimony from some prisoners and witnesses that indicates that they found this tactic to be extremely disturbing and degrading, leaving them with psychological scars.[29]

Although the once popular comparisons to "frat boy antics" supported the erroneous characterization of the acts at Abu Ghraib as evidence of bad behavior by a rogue element, the MP's performance of sexual degradation resembles the ritualized humiliation of soldiers by other soldiers that has been an accepted convention of military sexual culture for a long time. Scholars of the military have noted that among the consequences of a military culture that has historically condoned many forms of sexual aggression are the toleration of heterosexual rape, the exploitation of sex workers, and homophobic violence.[30] "Mock rapes" may occur as part of training for survival as a prisoner of war, while simulated and real acts of sodomy are accepted as part of informal initiation rites.[31] While it is highly likely that Charles Graner and company were following orders from interrogators, it is also likely that, lacking specific training in intelligence or interrogation, the MPs took recourse to ritualized forms of aggression that they already knew from military life.

There doesn't seem to be a consensus as to whether the use of sexual tactics was instigated by interrogators from the CIA, private contractors, military intelligence officers, or all three. Nonetheless, all three entities appear to have been involved. From what I have been able to glean from official

reports, witness and detainee testimony, and the stories of in-
terrogators themselves, sexual tactics in interrogation involve
sexual humiliation and homophobia, but less man-handling
than what was depicted in the Abu Ghraib photos. This would
conform to standard regulations restricting physical aggres-
sion in military interrogation, and also reflects the American
predilection for psychological coercion versus physical force.
Sexual tactics in interrogation are usually directed at one
prisoner at a time, in isolation. Whereas the purpose of pos-
ing prisoners in explicitly sexual ways for photographs was to
create embarrassing evidence that could be used to coerce
prisoners into becoming informants, the use of sexual tactics
in interrogation is aimed at "breaking" detainees by means of
an open attack on their masculinity.

The use of American female sexuality as a weapon
against Islamic enemies exploits a number of cultural biases
and archetypes. The stereotype of Arab masculinity as fragile
leads to treating it as a point of vulnerability, while the stereo-
type of women as less aggressive makes their sexual harass-
ment of detainees seem to be milder and more acceptable
than other forms of torture. We don't really have a language for
comprehending female sexual aggression as rape, which di-
minishes our ability to perceive it as such. Soldiers are trained

to rationalize any form of violence against the enemy that is permitted within given rules of engagement, and measure all demands made of their bodies against the ultimate sacrifice of death. At the same time, the proliferation of erotic exhibitionism both as subcultural practice and as popular cultural entertainment in late capitalist America generates a dominant interpretive framework for the participation in and witnessing of sexualized torture that favors a reading of it as something else: erotic play and illicit pleasure, for both the viewers and those viewed.

INTERROGATING INTERROGATION

At this point, Virginia, you may be thinking that, well, if the use of female sexuality in interrogation has come to light and the public is not making a fuss about it, why am I belaboring the issue? Women aren't exactly being forced to go to war, so the ones performing the infamous acts aren't doing so unwillingly. Prisoners will always complain regardless of whether their treatment is legally acceptable, and their advocates will always argue that carceral discipline is excessive. The pressures of war lead many involved to perform unusual duties. Perhaps we should consider it a measure of our equality that acts of sexual aggression may be included among those duties as long as there are "legitimate state interests" at stake? So, if terrorists crack because women sexually accost them in a manner that has been pre-approved by a superior officer, then we can chalk one up for the war effort. Call it "mild, non-injurious physical contact" and that will be the end of the story. Female interrogators and military police now have an arsenal of tactics they alone can draw on, a field of operational experience in which they can excel without having to deal with male competition—I say that in my performance and au-

diences look at me aghast, but isn't it true? I've even been reminded more than once by women soldiers that plenty of spies have used sex in past conflicts, so what is happening now is hardly new—there are just more women to do the work and more enemies to target. Sex work is nowhere near as stigmatized as it once was in America, and many feminists have argued that it is liberating. Why not concede that the military should benefit from the normalization of sexual exhibitionism brought about by its commodification in popular culture? Why not leave it to the experts to duke it out and determine when and where institutionalizing female sexual aggression as a weapon against captured enemies is acceptable?

Well, I didn't leave the matter alone because it bothers me. Every justification I find for these actions seems cynical, inhuman, and profoundly unjust. If the absence of consent makes sexual advances by men toward women punishable, why is it that women doing it to men get off the hook? It bothers me that this was happening and it bothers me that my peers are indifferent or even flippant about it. Postcolonial cultural theorists who purport to be critical of the current political order have determined that torture is simply an indication that systems of domination are running normally; while they may intend this conclusion as a warning, it seems to have been

taken as an invitation to forget about the issue.[32] I also find the playful speculation about the possible pleasures of such torture unnerving; has our submersion in a society awash in porn, comfortably distant from the atrocities of war, rendered us completely incapable of grasping what modern day sexual torture is? It bothers me that women in the military who are quick to complain about rampant sexual aggression in their workplace would find nothing questionable about sexually terrorizing prisoners with words and acts. How can they insist that they are taught the Geneva Conventions and then not find that thrusting sex at unwilling recipients constitutes excessively cruel humiliation? It bothers me that many feminists who responded publicly to the involvement of women in the Abu Ghraib prison abuse scandal seemed more concerned about it signaling a loss of innocence regarding women's capacity for violence than about the mounting evidence that the state is orchestrating sexual torture and using women to perform it. How different is that, I wondered, from having Condoleezza Rice invoke the long history of Civil Rights struggles to justify a protracted American control of post-Saddam Iraq? Is that only an indication of her opportunistic use of her own identity, or does it signify a cynical political project in which she willingly serves as a tool?

Discussions of the human rights issues raised by the evidence of torture in military prisons have been split between those who concentrate on the state and its agents as war criminals, on the systemic character of sexual abuse in the culture of prisons and the military, and on the moral deficiencies of the perpetrators. Critics who have offered theories as to how and why detainees have been subject to sexual torture have focused on the cultural specificity of the tactics more so than the ethics of instrumentalizing female sexuality as a weapon. Most feminists have avoided the question of how to address female sexual aggression being used as a weapon by insisting that the adverse conditions facing women soldiers is a more pressing issue affecting the majority of those who serve, that most women are "good soldiers," or that the "torture chicks" were unfairly singled out and were thus doubly victimized by the military and the media's treatment of the Abu Ghraib prison abuse scandal. As far as I'm concerned they've got their heads stuck in the sand. This country has a dark history of doing extremely violent things to some people so that others here can be "free"—and it has only been through insisting on the hypocrisy of that double-standard that democratic practices have been secured, protected, and expanded. That feminists would be reluctant to do so places them in complic-

ity with the very order they claim to want to change.

Only once have I come across a feminist argument that suggests that the Abu Ghraib photos might offer the opportunity to consider how and why women perpetrate violence. Angela Davis, who herself experienced incarceration and has engaged in decades of analysis of the politics and culture of prison life, has insisted that if we accept the social construction of gender, then we must understand that women can easily participate alongside men in established circuits of violence.[33] Davis sees women's interjection into the practice of torture as the product of the limitations of our country's civil rights strategies and discourses. In other words, equal opportunity for women in the twenty-first century has been interpreted as obtaining access to hierarchical institutions and power structures that perpetuate male dominance, racism, and American political hegemony.[34] Of course, few who gain access see their involvement in these institutions; on the contrary, their induction and training is designed to make them identify with conservative power structures as legitimate entities, and to see the exercise of force within guiding regulations as moral and politically justifiable and salutary for a democratic order. Freedom requires policing to safeguard its existence. What is really scary to me is how many American

women who aren't in the military think just like them.

I was taken back when I first came across the assertion in Brigadier General Janis Karpinski's memoir that she sees herself as part of a generation that led a feminist revolution within the military. How could feminism be reconciled with the goals of an authoritarian and patriarchal structure like the military? was my initial reaction. However, every woman I have had contact with in the past three years who has worked for the military has embraced a similar position. They all describe the military as an exceptional educational and work opportunity and as an economic solution. They characterize the military as a structure that challenges them and enhances personal characteristics such as assertiveness that enable them to advance professionally and eschew limiting traditional female roles and modes of address. Though many complain about sexual harassment, they believe in the system that is in place to address the bad behavior of the perpetrators, rather than viewing the culture of the military as a prevailing factor that remains untouched by this mechanism of redress. If fault is found, it always lies with individuals who do not live up to the promises of the institution, not with the institution itself.

Much has been said in the age of the voluntary army about the economic motives of those who sign up. The prom-

ises offered—education, debt payments, and sizable cash bonuses—are as attractive to young women as they are to young men with professional aspirations and minimal economic resources. But economics doesn't explain soldiers' participation in actions that most human beings would have great difficulty accepting. People involved in any psychologically or physically taxing form of work must learn to rationalize the risks and dangers involved. They are not just trained to have new skills—they are trained to see the world, the nation, people, war, and violence in particular ways. I learned that from my brother, who after two years of training could discern, upon arrival in a city, how to paralyze its infrastructure with minimal effort—and feel proud about that. It is that awareness of the power of conditioning that makes me reject the "bad apples" argument about those who committed acts of torture at Abu Ghraib, and opt instead to try to figure out how soldiers, particularly women soldiers, are taught to see what they do. I figure that at some point in the course of training they adapt themselves to their participation in violence on the job in two ways—they either justify the violence as a necessary duty, or they refuse to see their actions as being violent. And I imagine that interrogators and military police, by virtue of the repetitive nature of their duties handling and question-

ing prisoners, have eventually come to see these interactions and the social dynamics enacted in them as routine.

If training and heavy doses of patriotic ideology combined with the stresses of war can make torture appear acceptable to those in military service, then we are all susceptible. Even if the American public has not shown great interest in the ethical debates about torture, my hunch is that most of us find it absolutely intolerable. We prefer to believe that these terrible things have nothing to do with us because we are not sadists or psychopaths, and anyway, we didn't support the war. The perpetrators, on the other hand, chose to get involved, and may even have some proclivity toward violence. Seeing them as victims of bad circumstances and pathology provides solace, absolving everyone of responsibility while marking a safe distance between them and us. Even if the Stanford Experiment and the Milgram Experiment have shown the world that "good people can do bad things" when the proper conditions are in place, most of us prefer to believe otherwise. Popular culture's constant association of crime with pathology indicates just how attractive that link is. That is why I decided to cross the line. I decided to talk to interrogators. I didn't just want to know what they did or if they had tortured: I wanted to get a sense of who they are as people and what

their profession expects them to be.

There are some basic facts about the demographic that I could deduce from public records. Interrogators tend to be more educated than most in the military and see themselves as the intellectuals of the armed forces. There are many Mormons among them because Mormon missionaries are required to learn foreign languages, making them attractive candidates for intelligence work. Interrogators are supposed to know about the cultures their prisoners come from, but the high security needed to question terrorist suspects requires that they not be married or related to anyone from a potentially hostile country. Long sojourns in foreign lands, during which interrogators may have made friends with America's foes prior to their entry into the military, make them potentially suspect. The result of the view that an interrogator's proximity to other cultures is a potential security breach is that foreign-born nationals and ethnic minorities recruited for their linguistic and cultural knowledge remain at the bottom of the intelligence hierarchy, subject to greater suspicion of disloyalty. But these general bits of data about interrogators don't tell me what they are like, how they behave with others, and or what moves them.

I knew I couldn't bring an end to women's involve-

ment in torture by writing or making art about it, but at least I could make an effort to understand it through a dialogue that would help me and other civilians to look more closely at what soldiers do. Starting that conversation was not easy. Active duty military people are generally closed-lipped about their trade, and notoriously suspicious of anyone they identify as a leftist. Read just about any blog for pro-war soldiers and you will find plenty of pejorative epithets used to refer to those who criticize the war or the military. I had to figure out a way to meet them in a context in which they would be willing to talk. I am too old to join the Army, Virginia, and my checkered past as a left-leaning artist would probably nix my chances of acceptance anyway. If I had tried to get access as a journalist or researcher without an affiliation with the mainstream media, I would have been instantly pegged as a critic and denied access to anyone involved in classified activity. In any event, given how little experience I had with anything military, trying to interrogate interrogators would have led inevitably to failure.

I decided it was better to pose as a student; I knew I wouldn't come out an expert after a mini-course, but I would at least get a chance to engage with interrogators directly. I thought they would be more likely to talk about what they do

if they were in charge of the discussion and being paid to provide information. I soon found out through the Internet that there is a veritable industry of courses available on interrogation, operated by retired military and police. The War on Terror hasn't only spawned movies and TV shows, but has also engendered a wide range of pedagogical simulations that draw participants into a cultural imaginary of warfare. Some seem to be refresher or post-graduate courses for professionals in law enforcement. Others seem to be targeted at military aficionados. I would later learn that in Europe similar courses are also offered in "hostage-preparedness," tailored for corporate leaders, journalists and aid workers who travel to wartorn countries, to help them survive if they are kidnapped by terrorists. The courses are all modeled on the kind of training the teachers themselves receive. Soldiers learn a good deal through immersive simulation—they fight on mock-battlefields, take over mock-villages, and fly mock-planes. Some of them learn prisoner-of-war survival techniques by enduring several days in mock POW camps. Interrogators learn by interrogating other interrogators who are pretending to be prisoners.

I don't remember exactly how I found Team Delta, the group I ended up working with, but I noticed from their

website that they had appeared in television documentaries, which told me they weren't afraid of exposure and that I might therefore convince them to let me film them. The members are retired US Army interrogators who were in active duty in the 1990s and have since parlayed their skills in the private sector. The courses they offered are truncated adaptations of survival, evasion, resistance, and escape (SERE), including a course for elite forces designed to prepare them for resistance as prisoners of war. I would soon learn that many of the questionable interrogation tactics that have sparked recent investigations—waterboarding, sleep deprivation, extreme physical aggression—are precisely those that are used in SERE school training to represent mistreatment by enemies who do not adhere to the Geneva Conventions. It has been widely reported that SERE school psychologists and other instructors have been involved in the implementation of coercive tactics in military prisons.[35] I found it quite telling that supposedly forbidden torture tactics would be learned by US soldiers as the language of the enemy, making them at once familiar and un-American, thus easier to disavow. Having a systematic knowledge of those methods increases the likelihood of their being used as a last resort.

I chose not to tell them at first that I intended to bring

an all-female group. I was afraid that might raise a red flag, and that they might even think I was trying to make some sort of porn movie with a military theme. That was far from my intent: I wanted to see how the gender dynamics would play out between us and their all-male team, and I also wanted to observe how women responded to the training. I introduced myself in writing first as a university professor who was conducting research on military interrogation as political theater. However straight-laced that version of my intentions was, it was not an untrue characterization. I do see interrogation as a form of intercultural theater imposed upon an unwilling audience of one. For many human rights activists who seek to condemn the use of torture by the US military, considering interrogation as a form of performance and as a kind of political theater might seem like a distraction, or even a perverse avoidance of the "real" issue. I believe this view is shortsighted and logically flawed. Torture is indeed painfully real, but theater and performance are crucial to making it work. The tortured person is made to believe that things may happen through illusions created by the combined effects of stress and suggestion. Theatrical devices are put to the service of coercion. Soldiers learn to disassociate emotionally and psy-

chologically from the violence they perpetrate by developing interrogator characters in the same way that actors shape their personae.

The interrogator in charge of the course, Mike Ritz, surprised me in many ways. He wasn't at all taken back by being contacted by a professor—in fact, he let me know right away that they constituted a sizable portion of his clients. He accepted me and the six other women in my group as students despite his perception of us as leftists and potential critics of the military; he allowed me to film our experience with him; and subsequently, he agreed to engage in public dialogue with academics and students about the implications of his work. During the training, he was a consummate professional, at ease fielding all sorts of questions about the ethics of interrogation, and fluent in the psychological theories that inform the military's methods and assessment of character. He was also implacable and at times impenetrable, which frustrated many of the members of my group who wanted badly to outsmart the teacher. He always seemed to find the shortest answer to anything we asked. When I made cautious attempts to question him about the evidence of the use of torture in interrogations, or about unexplained prisoner deaths in custody, he would simply become silent for a brief period

and then change the subject. I found it unsettling that he was so difficult to read as a person, even though I now understand that this is a learned trait he used in his work. I could never really be sure what he thought, no matter how forcefully he expressed himself.

The course that he gave us, together with his colleague Marshall Perry, lasted three days. Upon arrival, we received a mission, a code, and a contact number, and that was the information we were not supposed to divulge. The following morning our immersive simulation experience began. We the students were ambushed, captured, strip-searched, and thrown into a mock POW camp in the Pocono Mountains. Each of us was subject to four interrogations over the course of a day. Afterwards, we were de-briefed, our instructors assessed our attempts at resistance and our general performance. Then we spent two days in classroom training, learning about the tactics of interrogation that the military uses, and attempting to deploy some of those tactics in exercises in which we interrogated our teachers.

Our efforts were embarrassingly bad. Lesson number one for those in the group who secretly believed that interrogators are sadists by nature was that only highly trained profes-

sionals can actually do the job effectively. Lesson number two was that interactions in interrogations are organized through an elaborate network of charts, grids and terms. Thinking this way about talking to another person made the emotional aspect of conversation evaporate. Everything, from the direction of a prisoner's eye movements to his ability to repeat himself accurately, fits into that elaborate system. The preliminary assumption is that information is being sought from an unwilling source. The next assumption is that methods drawn from behavioral psychology can render people transparent and controllable despite their efforts to resist. The interrogator is taught to see himself as the master translator who maps prisoners' behavior and interprets the expressiveness on the surface of their bodies and in their voices as indications of sincerity, reliability, and truthfulness. While the interrogator has an arsenal of tactics as his disposal, his greatest leverage is the imbalance of power between captor and captive. The prisoner has already lost control over his life, his person, his possessions, and his movements before he enters an interrogation room. His thoughts are his last possessions. Information is his only currency.

Being at the mercy of your captor is not a condition that can be simulated in training. Nonetheless, the pressures

applied through the various modes of questioning, dissimulation, and forms of stress are supposed to undermine anyone's ability to engage in subterfuge. Everyone in my group was surprised at how much trickery was permitted and how effective it was for inducing fear and producing confession. We fell for fake documents and stand-ins who withstood fake beatings. We lost any clear sense of where we were or what was happening around us from having hoods on our heads, and that made us accept being led, and then angry at ourselves for accepting. We felt stupid when the teachers saw through our lies. They, on the other hand, were gloating amongst themselves about how quickly they could disarm us psychologically. Kayla Williams observed in her memoir that she could see how easy it was for interrogators to become enamored of the power they have over others—and just how dangerous that could be.[36] I agree. There was little more at stake in our case than some money and pride in a job well done. But it wasn't hard to imagine how such a situation could spin out of control when real frustration on both sides escalated. Interrogators who have spoken out in recent years have acknowledged that incessant demands for intelligence from above pushed them into using harsher methods. Furthermore, in an insurgency

there are few opportunities to meet the enemy in person; the symbolic value of prisons and their interrogation rooms as sites of revenge should not be underestimated.

The women who attended with me were all skeptics regarding the military. Some of them had an interest in war or militarism as artistic subject matter. One woman had worked with victims of torture and wanted to experience the scenario from the other side of the table. A couple of the members of the group were curious as to whether this kind of training was comparable to sadomasochistic practices. I did my best to share with them what I knew about the course and the teachers before we went, and asked them each to decide whether they would go through with the experience and stick to it regardless of discomfort. I tried to convince them that we would elicit more information about how interrogation worked if we did not turn every classroom exchange into a political discussion about Abu Ghraib. I tried to dispel the fears that some of them had even before we started that the interrogators would actually become too brutal for us to handle.

Mike had told me in our first conversation that all an interrogator really needed to do was plant fear in one's head and let the mind do all the work. That was a rather innocuous way of describing the use of threats, but it showed me

from the start how the language used to describe coercion could make it appear less insidious, and make the interrogator look blameless. In any case, he was right: the forms that we were asked to fill out before arriving had several questions that made my group members very nervous. Were we asked to identify our phobias so that they would be used against us? Did we have to sign a release absolving Team Delta of responsibility if we died during the course because they might actually kill us? I tried to explain that no company offering courses on interrogation would survive if the teachers made killing clients routine, but that did not stop their minds from racing to imagine the worst. Nor would the artificial character of our immersion prevent the members of my group from breaking under stress. Out of seven of us, four were unable to resist the interrogators and divulged the information we were supposed to hide. A few people cried, and two lost their tempers with the teachers and broke character. As far as I could tell, it was the combination of being disoriented by long periods under a hood, being frustrated by the ongoing verbal aggression, and being tired from extended periods of forced exercise that unnerved people. The experience became a study in the physiological reactions to stress. Danger doesn't have to be real to instill discomfort; it just has to feel jarring enough to effect

destabilization.

I would never suggest that our experience was comparable to that of a prisoner, because we were not taken against our will, and we knew throughout that we could stop the simulation with a simple request. However, I was not aiming to understand what a prisoner goes through, but rather what a soldier understands him or herself to be doing. Soldiers all endure substantial amounts of discomfort and ritualized humiliation as part of their training. They experience geographic dislocation, alienation from their social context, deprivation of privacy, enforced uniformity of appearance—which are also aspects of the prison experience. Former prisoner Moazzam Begg writes in his memoir that many MPs he met during his internment told him, "We're like you, only our prison is larger."[37] While Begg disagreed vehemently, it is telling to me that the soldiers see themselves in this way. They are often compelled to operate in life-threatening conditions, to kill and witness death. All these factors contribute to their understanding of pain, and I would add to their desensitization. It is not unusual to measure the pain of others by our memory of what we have endured.

None of what I have described about my experience with these interrogators pertains directly to the gender issues

that sparked my inquiry. My teachers were reluctant to talk about the gender divide, insisting that we were students first and foremost. Perhaps they feared recrimination from my group, or simply thought it wise to sidestep the issue. But in the course of our interaction with them, their views on gender differences would pop up from time to time, and they were a strange mix of determinist assumptions and liberal concessions of equality; women are "less rational and more compassionate," but we are free to serve in the military if we wish. It was clear that they were accustomed to being wary of potential accusations of sexual harassment because of the nature of the training—they refused, for example, to remove our underwear during strip searches and decided against staging a mock-rape during the course. They warned us that they might pull out sexist insults from their conceptual toolboxes to irritate us during interrogations. We were treated to lectures on "why men will always rule the world" and how women all felt they had to prove something to everyone because of their own professional insecurities. We were called stupid girls and cunts by guards and ordered to dance like Rockettes while we were in the pen. In the classroom our teachers suggested to us that female interrogators could excel by playing dumb and pretending they were not involved with military intelligence at

all. We were frequently warned that if we tried to play tough in an interrogation and didn't have the physique or the voice to back up the tactic, we would be laughed out of the booth. None of the members of my group were deeply affected by these sexist comments because their delivery lacked the venom we associate with real harassment. The men were being cautious, and it showed.

So did these guys seem evil or diabolical? No. If anything, they seemed to be resolutely pragmatic about everything they did and said. Did they appear to be uncontrollably violent? Not at all. In fact, the guards' resorting to caricatured harassment seemed to indicate that they were actually somewhat uncomfortable being mean to us. Did the interrogators' understanding of what they were doing seem reasoned? Yes. That was perhaps the clearest indication of their having been trained to accept things that my group found troubling. They have no trouble with the use of force as long as they can justify it as necessary. In their world, everything, including hurting people, can be rationalized. That doesn't mean they can't recognize wrongdoing, but their threshold is very different from mine. I imagined that they had been hardened by having to make life-and-death decisions in situations I had never been through. But the latitude they had within the

rules of war was alarming to me. The experience made me respect them, and at the same time, fear even more for those are detained.

Interestingly, only one of the women in my group succeeded in convincing them into thinking she was really sick and needed a doctor. We had been briefed quickly upon arrival on resistance tactics and encouraged to feign illness to avoid hard treatment. But I think most of the group wanted to "win" by playing tough and outsmarting the guys. Only Fabienne, who hung her head, cried, and moaned "I don't know" to everything, fooled them. She got extra water and was relieved from two out of four interrogations. She also got a quick medic inspection. The interrogators eventually figured out that she was play-acting, but she swayed them for a moment or two. That was enough for them to concede and acknowledge her successful resistance in the debriefing. The interrogator who had called in the medic admitted he was angry that she had fooled him. I found it quite telling that it was the woman who acted like a weakling who performed the most convincing persona for these interrogators.

The same persona that these men found believable is the one that female soldiers I talked to and read about found annoying, albeit occasionally expedient. Acting flustered or

incompetent, they admitted, might help in a pinch when fa-
vors are needed from strangers. However, those who sought
to advance themselves openly claimed that they did whatever
was possible to distance themselves from behaviors associ-
ated with feminine weakness or vulnerability. Janis Karpinski
recalls setting standards for herself in physical training that
showed she was stronger than what the military required of her
as a woman.[38] Kayla Williams writes disdainfully about female
soldiers who cry in public or wear makeup to work as if their
behavior constitutes a set-back for all women in the armed
forces.[39] Is this the female version of the prevailing tendency
among men in military culture to demonize and denigrate
weakness? It seemed to me that they were very self-conscious
about gendered expectations of their ability to perform, and
they were seeking to refashion prevailing female stereotypes
through their own conduct. I have also heard rumors from a
number of sources about female soldiers who provide sexual
favors to male soldiers for money. This suggests that some
women have taken it upon themselves to capitalize on rather
than contest offers that other women interpret as harassment.
It also complicates the issue of whether the strategic use of
female sexuality in military culture is exclusively orchestrated
from above.

As you can see by now, Virginia, the question of how women are waging war is not simply a matter of their actions, but also of how the images of what they are can be used against the enemy, and against themselves. Working with stereotypes is not only the byproduct of a sexist environment, but also a crucial component of interrogations where the drama of the exchanges is painted in broad strokes. The types women embody and deploy are not only culturally specific but age appropriate. Thus, while younger women may be divided into "bitches and sluts" as Kayla Williams writes, the women who have risen to high-ranking positions have done so by evincing a steely demeanor. Major General Barbara Fast, who was the top intelligence officer in Iraq during the high point of the Abu Ghraib prison abuse scandal, took an extremely hard line against releasing "security detainees," systematically rejecting requests submitted by interrogators who found that those being held had no intelligence value. She was rewarded by being given the directorship of the US Army Intelligence Center at Fort Huachaca.

So why is it then, that when I get up on stage in uniform to speak about women engaging in sexual torture as a logical and reasonable means of winning the War on Terror, I find that many in my audiences claim that I've "wounded

them" by implicating feminism in something so terrible? Even more disturbing to me are the younger women who want to ignore the issue of torture and instead consider my training experience as a foray into sadomasochism. There is something deeply tragic for me about this feminist blind spot, and recognizing it as such has been the saddest part of my journey. It may be very difficult and even painful for those of us who support gender equality and seek the elimination of entrenched cultural biases against women to imagine ourselves as voluntary and conscious perpetrators of violence. But it is high time that we recognize that it is nothing short of a lie to frame American women's experience exclusively in terms of powerlessness. At present, the left and the right take advantage of the lack of terminology for discussing the ways in which we exercise power over others. If we persist in viewing female aggression as stemming exclusively from our own victimization or psychosis, we have no way to address serious and real ethical and political questions emerging from women's involvement in systems and structures of dominance. If we refuse to address the ways that women embrace power then we deny ourselves the means of understanding how conservative forces exploit identity politics. Neo-conservatism promises access to political power to all those who shirk

identification with minoritarian "special interests" while at the same time capitalizing economically on the visible evidence of gender and ethnic difference that the presence of women and minorities provides.

It is disingenuous to argue that, because of our nature or our experience as victims of gender oppression, women maintain a higher ethical standard regarding the use of aggression for anything other than self-defense. There certainly is little evidence that this is true in the US in 2008. Nevertheless, various prominent feminists have expressed their disappointment at the actions of Condoleezza Rice and Lynndie England, because their respective words and deeds signal the loss of an imagined moral high ground we as women supposedly occupy as members of an historically oppressed social group. Admittedly, I also cringe at most of what Condi says, and felt repulsed by the goofy smiles on the faces of Lynndie England and Sabrina Harman as they posed for the camera with their victims. But focusing on their personal shortcomings distracts us from addressing the existence of two seemingly opposed but nonetheless concurrent truths: first, American women continue to experience sexism; and second, thanks to their participation in the exercise of global power as Americans, women are called upon and agree to

act in public capacities as aggressors, frequently by making strategic use of their femininity.

I have always thought of you as a trailblazer, Virginia, however much of an elitist aesthete you may have been. When I was a student, I admired the caustic tone of your political arguments, your righteousness, your defense of the intellect, your demands for artistic freedom for women as well as men. Your feminist vision, however limited it was regarding the social conditions of the majority, focused on issues that I could identify with as a young woman writer trying to find her voice. But I could not have anticipated that in the years to come, women would cling to your arguments in order to avoid disturbing truths. I may have angered your disciples by dragging your work through the morass of the present. I'd like to believe that you would actually approve.

1. Woolf, Virginia, *A Room of One's Own* (New York: Penguin Classics, 2002).

2. I am referring to the performance piece that I created called *A Room of One's Own: Women and Power in the New America*, that premiered in 2006 in London and toured to New York, Miami, Philadelphia, New Haven, and New Zealand. I also made a video documentary about training with retired US Army interrogators called *Operation Atropos* (59 mins, 2006).

3. Berlow, Alan, "Who Would Antonin Scalia Torture?" Salon.com, January 2, 2008, www.salon.com/opinion/feature/2008/01/02/lethal_injection/print.html.

4. The films *Rendition* (2007), *Lions for Lambs* (2007), and *Redacted* (2007) all disappeared from movie theaters shortly after their release.

5. Woolf, Virginia, *Three Guineas* (New York: Harcourt, Inc., 2006).

6. Ibid, p. 14.

7. Sontag, Susan, "Regarding the Torture of Others," *New York Times Magazine*, May 23, 2004, http://www.nytimes.com/2004/05/23/magazine/23PRISONS.html?ex =1400644800&en=a2cb6ea6bd297c8f&ei=5007&partner=USERLAND.

8. Sturken, Marita, *Tangled Memories: The Vietnam War, the AIDS Epidemic and the Politics of Remembering* (Berkeley: University of California Press, 1997), p. 92.

9. Reuters, "Pentagon Confirms Guantánamo Sex Tactics," February 10, 2005, http://news.yahoo.com/news?tmpl=story&u=/nm/20050210/us_nm/.

10. Tony Lagouranis makes this argument throughout his memoir, *Fear Up Harsh: An Army Interrogator's Dark Journey Through Iraq* (New York: New American Library, 2007), p. 17-18. Chris Mackey also complains in *The Interrogators* (see note 16 for full citation)about the deleterious effect of the presence of OGAs (other government agencies). In addition, investigative journalist Seymour Hersh and military historian Alfred McCoy have both argued that sexual torture as a tactic originated within the CIA as a special access program and that its implementation by US soldiers is the result of the presence of both the CIA and private contractors inside military prisons. See Alfred McCoy's *A Question of Torture: CIA Interrogation from the Cold War to the War on Terror* (New York: Henry Holt and Company, 2006) and Seymour Hersh's *Chain of Command: The Road from 9/11 to Abu Ghraib* (New York: Harper Collins, 2004).

11. Lagouranis and Mikaelian, *Fear Up Harsh*, p. 17-18.

12. Saar, Erik and Novak, Viveca, *Inside the Wire: A Military Intelligence Soldier's Eyewitness Account of Life at Guantánamo* (New York: Penguin Press, 2005), p. 223-227.

13. Beaver, Staff Judge Advocate Diane E., "Memorandum for Commander, Joint Task Force 170, Department of Defense," *Administration of Torture*, eds. Jameel Jaffer and Amrit Singh (New York: Columbia University Press, 2007), p A-93.

14. *The Schmidt Report, Investigations into FBI Allegations of Detainee Abuse at Guantánamo Bay, Cuba Detention Facility*, published June 9, 2005, p. 7-8, http://www.cfr.org/publication/9804/schmidt_report.html.

15. The most comprehensive account of detainee experiences I have found is Andy Worthington's *The Guantánamo Files: The Story of the 774 Detainees in America's Illegal Prison* (London: Pluto Press, 2007).

16. Mackey, Chris and Miller, Greg, *The Interrogators: Task Force 500 and America's Secret War Against Al Qaeda* (New York: Little, Brown and Company, 2004).

17. Begg, Moazzam, and Britain, Victoria, *Enemy Combatant: My Imprisonment at*

Guantánamo, Bagram and Kandahar (New York: The New Press, 2006).

18. Mackey and Miller, p. 377.

19. Ibid, p. 481-482.

20. Ibid, p. 422.

21. Several internal and Congressional investigations of sexual harassment in the US military have been conducted in the past fifteen years in response to widely publicized incidents, such as the Tailhook scandal of 1991. The Air Force maintains a website with a bibliography of internet sites, books, periodicals, and documents relating to the issue at http://www.au.af.mil/au/aul/bibs/sex/haras.htm.

22. Williams, Kayla, and Staub, Michael E., *Love my Rifle more than You: Young and Female in the US Army* (New York: W.W. Norton, 2005), p. 247.

23. Ibid, p 248.

24. Spec. Luciana Spencer of the 205 MI Brigade was cited in the Taguba Report for forcing a prisoner to strip and walk naked in front of other prisoners at Abu Ghraib. See http://www.washingtonpost.com/wp-srv/world/iraq/abughraib/timeline.html.

25. Worthington, p. 205.

26. Ibid, p. 198

27. Huskey, Kristine A., "The Sex Interrogators at Guantánamo," *One of the Guys: Women as Aggressor and Torturers*, ed. Tara McKelvey (Emeryville, CA: Seal Press, 2007), p. 176.

28. Lagouranis, p. 17.

29. Khoshaba, Riva, "Women in the Interrogation Room," *One of the Guys*, p.179-187. See also the letter from T.J. Harrington, deputy assistant director, FBI Counterterrorism Division, to Major Gen. Donald J. Ryder, Department of the Army, relating three incidents in which military interrogators used "highly aggressive interrogation techniques." Jaffer, Jameel and Singh, Amrit, *Administration of Torture* (New York: Columbia University Press, 2007), p. A-127. This document is reproduced in the following section.

30. Hillman, Elizabeth, "Guarding Women: Abu Ghraib and Military Sexual Culture," *One of the Guys,* p. 113.

31. Ibid.

32. Puar, Jashir K., "Abu Ghraib: Arguing Against Exceptionalism," *Feminist Studies*, 30, no. 2 (Summer 2004), p. 522- 534.

33. Davis, Angela Y., *One of the Guys*, p. 26.

34. Davis, p. 27.

35. Benajmin, Mark, "Torture Teachers: An Army document proves that Guantá-

namo interrogators were taught by instructors from a military school that trains US soldiers how to resist torture," Salon.com, June 29, 2006, http://www.salon.com/news/feature/2006/06/29/torture/.

36. Williams, p. 205-206.

37. Begg, p. 128.

38. Karpinski, Janis, and Strasser, Steven, *One Woman's Army: The Commanding General of Abu Ghraib Tells Her Story* (New York: Hyperion Books, 2005).

39. Williams, p. 91-95.

FBI MEMO

The US Naval Base at Guantánamo started receiving prisoners captured in Afghanistan in January 2002. By the fall, high-level authorization for the use of harsh interrogation methods had been obtained from the then Defense Secretary Donald Rumsfeld. The FBI began to express objections to the military about coercive interrrogation methods that were used at Guantánamo in the latter part of 2002. The following FBI memo from 2004 contains a description of an interrogation that an agent observed in late 2002 involving a female interrogator who made sexual advances as part of her approach to a prisoner.

OCT 27 2004 9 24AM ~SECRET~ NO 354 P 2

U S Department of Justice

Federal Bureau of Investigation

Washington, D C 20535-0001

July 14, 2004

Major General Donald J. Ryder
Department of the Army
Criminal Investigation Command
6010 6th Street
Fort Belvoir, Virginia 22060-5506

Re. Suspected Mistreatment of Detainees

Dear General Ryder

 I appreciate the opportunity I had to meet with you last week. As part of a follow up on our discussion on detainee treatment, I would like to alert you to three situations observed by agents of the Federal Bureau of Investigation (FBI) of highly aggressive interrogation techniques being used against detainees in Guantanamo (GTMO). I refer them to you for appropriate action

 1 During late 2002, FBI Special Agent ▮▮▮▮▮ was present in an observation room at GTMO and observed ▮▮▮▮▮ (first name unknown) ▮▮▮▮▮ conducting an interrogation of an unknown detainee. (SA ▮▮▮▮▮ was present to observe the interrogation occurring in a different interrogation room) ▮▮▮▮▮ entered the observation room and complained that curtain movement at the observation window was distracting the detainee, although no movement of the curtain had occurred. She directed a marine to duct tape a curtain over the two-way mirror between the interrogation room and the observation room SA ▮▮▮▮▮ characterized this action as an attempt to prohibit those in the observation room from witnessing her interaction with the detainee Through the surveillance camera monitor, SA ▮▮▮▮▮ then observed ▮▮▮▮▮ position herself between the detainee and the surveillance camera The detainee was shackled and his hands were cuffed to his waist. SA ▮▮▮▮▮ observed ▮▮▮▮▮ apparently whispering in the detainee's ear, and caressing and applying lotion to his arms (this was during Ramadan when physical contact with a woman would have been particularly offensive to a Moslem male). On more than one occasion the detainee appeared to be grimacing in pain, and ▮▮▮▮▮ s hands appeared to be making some contact with the detainee. Although SA ▮▮▮▮▮ could not see her hands at all times, he saw them moving towards the detainee's lap He also observed the detainee pulling away and against the restraints Subsequently, the marine who had previously taped the curtain and had been in the interrogation room with ▮▮▮▮▮ during the interrogation re-entered the observation room

b6 -1,2
b7C -1,2

66F-HQ-A1234210 DETAINEES-3823
TJH.tjh (2)

~SECRET~

Oct 27 2004 S 2471 ┤SECRET├ Ja. 05- P 3

General Donald J. Ryder

b6 -1,2
b7C -1,2

SA[____] asked what had happened to cause the detainee to grimace in pain. The marine said [____] had grabbed the detainee's thumbs and bent them backwards and indicated that she also grabbed his genitals The marine also implied that her treatment of that detainee was less harsh than her treatment of others by indicating that he had seen her treatment of other detainees result in detainees curling into a fetal position on the floor and crying in pain.

b1
b6 -1,2,5
b7C -1,2,5

2. Also in October 2002, FBI Special Agent [____] was observing the interrogation of a detainee when [____] a civilian contractor, came into the observation room and asked SA [____] to come see something SA [____] then saw an unknown bearded long-haired detainee in another interrogation room [____] SA [____] asked Mr [____] whether the detainee had spit at the interrogators Mr [____] laughed and stated that the detainee had been chanting the Koran and would not stop. Mr [____] did not answer when SA [____] asked (S)

b6 -4
b7C -4

3 In September or October of 2002 FBI agents observed that a canine was used in an aggressive manner to intimidate detainee [____] and, in November 2002, FBI agents observed Detainee [____] after he had been subjected to intense isolation for over three months. During that time period [____] was totally isolated (with the exception of occasional interrogations) in a cell that was always flooded with light By late November, the detainee was evidencing behavior consistent with extreme psychological trauma (talking to non-existent people, reporting hearing voices, crouching in a corner of the cell covered with a sheet for hours on end) It is unknown to the FBI whether such extended isolation was approved by appropriate DoD authorities

b6 -2
b7C -2

These situations were referenced in a May 30, 2003 electronic communication (EC) from the Behavioral Analysis Unit of the FBI to FBI Headquarters. That EC attached, among other documents, a draft Memorandum for the Record dated 15 January 2003 from Capt [____] (USAFR), that refers to the first two events among others in a time line of events related to discussions concerning the use of aggressive interrogation techniques Marion Bowman of the FBI's Office of General Counsel discussed the contents of those communications with Mr Dietz, Deputy General Counsel (Intelligence) and Mr. Del'Orto, Deputy General Counsel of DoD, around the time the EC was received Although he was assured that the general concerns expressed, and the debate between the FBI and DoD regarding the treatment of detainees was known to officials in the Pentagon, I have no record that our specific concerns regarding these three situations were communicated to DoD for appropriate action

2

┤SECRET├

DETAINEES-3824

OCT 27 2004 9 25A 1 (**SECRET** — 'C 25J P 4

General Donald J. Ryder

If I can provide any further information to you, please do not hesitate to call.

Sincerely yours,

T J. Harrington
Deputy Assistant Director
Counterterrorism Division

DETAINEES-3825

3

SECRET

OUR FEMINIST FUTURE

The Museum of Modern Art organized a symposium in January 2007 called "The Feminist Future," and I was invited to speak. It was a landmark occurrence, the first time that MoMA publicly acknowledged the significance of feminist art and art history. The conference coincided with two exhibitions of feminist art: "WACK!: Art and the Feminist Revolution" at the Museum of Contemporary Art in Los Angeles, and "Global Feminisms" at the Brooklyn Museum. These events generated an enormous amount of discussion in the media and in the academy about whether feminist art had "arrived," and whether feminist art history had been mainstreamed. This view of the state of feminist art seemed somewhat out of sync with reality to me—first, the art world continues to be hostile to all practices that politicize aesthetic values and ruling tastes. Second, neither MoMA nor MoCA were committing to acquire feminist artworks, which would have constituted a much stronger form of recognition of feminism's "value." I decided to use my fifteen minutes on a MoMA podium to perform as a visitor from the US Army who had arrived to congratulate my peers in the art world for their strategic containment of feminism and their effective use of women.

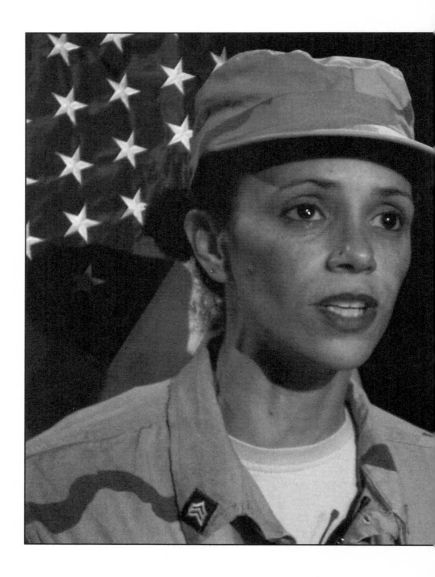

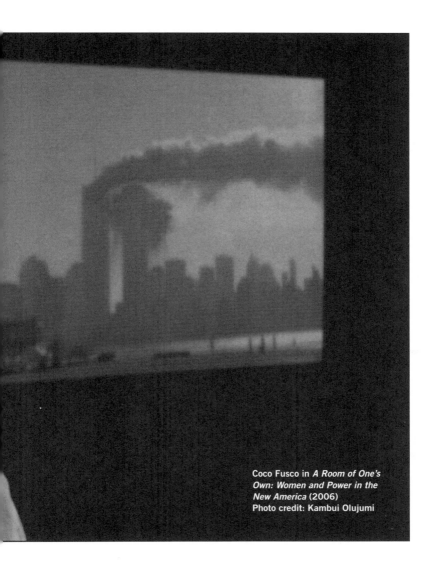

Coco Fusco in *A Room of One's Own: Women and Power in the New America* (2006)
Photo credit: Kambui Olujumi

Good Morning And God Bless America.

For the past several months I have been briefing the civilian community on the subject of female interrogators and their use of sexual innuendo as a crucial weapon in the fight against global terrorism.

I do so to make it more widely known that the War on Terror offers women an unprecedented opportunity to demonstrate our strength and charm by providing us with an enemy for whom sexuality is a key weak point.

We exploit the vulnerability that is common to Islamic fundamentalists in order to get them to cooperate with us. The sexual freedom women gained in the course of the twentieth century has turned out to be a highly effective means of disarming our enemies.

As female interrogators we can take advantage of the fact that the male populations of traditional societies cannot conceive of us as powerful or violent, much less as highly trained military officers. Thus we use the tried and true B&B tactic, posing as "bimbos and babes" to extract actionable

intelligence without them knowing what is happening to them.

Today's event about the feminist future gives me an opportunity to make more general comments about American women's relationship with power of freedom.

Many of us in the military feel a kinship with those of you in the arts. Military intelligence involves the careful study of culture, and like you, we seek to understand people's beliefs and learn how to shape them.

As an interrogator, I feel a particular kinship with performance artists, even if I don't always share their views. To my mind, interrogation is a form of performance for an audience of one—a captive audience, so to speak. We have to know how to play our roles well so that we make our audience believe what we want them to believe.

Many of you here today may not have considered this, but the military and the art world are similar in many other ways as well. Both institutions are guardians of this country's sacred freedoms. We are both hierarchical in structure, and

global in scope. We maintain amicable and productive relations with multinational corporations, and our operations run best when unsavory details remain far from public view. We both know that the surest way to hide things is to put on a good show.

In fact, the military has learned a great deal from the arts about how flashy spectacle draws public attention away from the less uplifting aspects of our engagements. We have also taken a cue from you about how to ensure press cooperation by limiting access to our special events to those in the media who share our views.

Today I would like to take a moment to commend the art world for its strategic integration of women, and bring to your attention the fact that some of the tactics we developed for gender management have also been useful to you.

From a military perspective it seems that you have found excellent ways to deflect attention that could have continued to be a serious problem in the wake of the tumult of decades past.

I think you all know what I am talking about here—those troublesome forms of dissent that interfere with the smooth running of daily operations by creating public scandals that tarnish your reputations as benevolent arbiters of creative talent and public interest.

The US military has also had to grapple with gender management. I am not referring here to the issue of sexual harassment, although we in the military agree with the art world's de facto policy of denying its existence. Faced with a shortage of manpower after the draft ended in the 1970s and an expanding theater of operations in the age of global warfare, the US military began to accept women and integrate them into areas from which they had previously been barred. Every year since then, women in the armed forces have gotten closer and closer to combat and have moved up the ranks in military intelligence.

At the same time, the military had to make sure that this move could not be perceived as a form of weakness by others inside or outside our country. We could not allow this to seem as though there was shortage of male talent, or even worse, as if this was a concession to the demands from

subversive left wing types. We could not allow the presence of women to weaken the military as a unified structure by openly engaging with that radical fringe of the female population that proudly call themselves feminists.

The challenge then, for political and military strategists, has been to capitalize on female ambition while at the same time severing the attraction to power from the desire for change— what I believe some of you here call the urge to dismantle patriarchy.

We had to train our recruits to embrace the golden rule that in order to be good soldiers they have to stop thinking about being women. Now it seems to me that you have all been very successful at convincing the young among you that in order to be good artists they have to stop thinking…about being women, or just about anything else.

Fortunately for you and for us, the political conservatism of the Reagan era and its aftermath has pretty much guaranteed that most of our recruits these days aren't very interested in or attracted to radical tendencies of feminism from the chaotic period of the 1960s and 1970s. What they do

know is this: the personal is profitable as long as the political is inimical to it. That said, one of the unfortunate consequences of living in a free society is that we must contend with antisocial elements that seek to put the blame for their own shortcomings on something outside themselves.

Their insecurities are exploited by the feminist dinosaurs that continue to walk the earth and talk up a storm, protected by special interest lobbies that control most colleges and universities.

Most of the women who join our ranks these days have stayed away from them, but nonetheless, it is always better to have a plan for contending with potential disruption, or even better, for preemptive strikes against the return of radicalism.

So here is a list of recommendations from your allies in uniform. We've just adapted the strategies we use to suit your more free-wheeling domain.

Remember that the goal is to find every way to make women's achievement seem antithetical to feminist politics. Make

sure to show that lots of attractive and appealing women already cooperate in, if not lead, this process:

1. DON'T DENY, CONTAIN
Give feminism a place in art history as part of the past, thereby burying it so it will not been seen as a force among the living.

2. TOKENISM, NOT QUOTAS
Reward female conservatives so that they may serve as role models.

3. YOU'VE GOTTA HAVE FRIENDS
Enlist sympathizers in the media to argue that the financial success of an excessively visible minority of women artists is an obvious indicator that feminism achieved all its goals for the arts and is therefore obsolete.

4. BITCH YOUR WAY TO THE BANK
Celebrate rebellion for rebellion's sake. This strategy is especially effective for channeling the energies of recruits who seek to be the kind of "bad girls" that attract favorable attention. Erratic behavior and erotic exhibitionism can fill the tab-

loids, be emblazoned on the labels of hip women's products, or be easily sold at numerous prominent art galleries.

5. FAIR AND BALANCED

Aim for "balance" in public discourse by giving opponents to feminism a place at every table as if they were a disadvantaged minority in need of affirmative action. This helps to create the impression that feminism is hegemonic, even though the social and political conditions of women in the world suggest the opposite.

6. TOUCHY FEELY DOES IT EVERY TIME

Remember that while art historians may feel obliged to acknowledge feminism, artists don't. Take advantage of the apparently unscripted and personal nature of studio visits. Communicate to aspiring art stars that their imagination is best protected by avoiding any discourse that requires them to consider their relationship to a group. It won't be hard, just gush with enthusiasm when they ramble on and on about their favorite songs, their toys, their dogs, and their boyfriends.

That's all there is to it, ladies and gentlemen, just six easy steps that are guaranteed to work. The benefit of using rewards rather than punishment is that your opponents will be completely disarmed—and they'll seem exceedingly unattractive. Besides, in a field full of unruly upstarts, you've got to avoid making it seem like there are a lot of rules. In the military we learned that lesson the hard way. Remember all the flack we got from the special interest groups about Don't Ask Don't Tell for homosexuality?

It took a full-blown war for us to get out of that mess.

But I guarantee that if you keep on following the six easy steps I just outlined for you, you will get the same results without having to impose a policy or hire a spin doctor.

Everyone will have forgotten that there was ever supposed to be a feminist future.

Thank you and good day.

A FIELD GUIDE FOR FEMALE INTERROGATORS

In the widely publicized debates about harsh military interrogation methods, many allusions have been made to various manuals detailing authorized methods that have been issued by the military and the CIA since the 1960s. These manuals circulate publicly on the Internet. While many recent investigations of abuse in military prisons have addressed the use of sexual aggression by interrogators and military police, these tactics are not explicitly described in any manual, nor are the specific methods used by female interrogators mentioned. As part of my exploration of the role of female sexuality as a weapon in the War on Terror, I decided to create a manual that illustrates the sexual tactics that female interrogators have been reported to be using. All the scenes in the illustrations are based on the testimony of detainees and eyewitnesses. *The illustrations for this manual were made by Dan Turner.*

INTRODUCTION

The purpose of this handbook is to present basic information about coercive techniques available for use by the female interrogators of CENTCOM. It is vital that this data not be misconstrued as constituting authorization for the use of coercion at field discretion. There is no such blanket authorization.

All coercive techniques are designed to induce regression. Calculated application of the pressures detailed herein can make the source's mature defenses crumble as he becomes more childlike.

Coercive procedures are designed to exploit the resistant source's internal conflicts and induce him to wrestle with himself. The chances of success rise steeply if the coercive technique matches the source's cultural background. Psychological studies of Islamic cultures suggest that strict adherence to religion increases Muslim men's susceptibility to sexual innuendo, particu-

larly when that pressure is applied by non-Arab females. One subjective reaction often evoked by coercion is a feeling of guilt. The interrogator, by virtue of her role as the sole supplier of satisfaction and punishment, assumes the stature of a parental figure for the source. It is not unusual for warm feelings also to develop. If the interrogator nourishes this ambivalence, the guilt may be strong enough to influence the source's behavior and make compliance more likely.

The last step of a fruitful interrogation is the attempted conversion. Interrogatees should not be squeezed and forgotten. Such pragmatic indifference is short sighted. A successful conversion can lead to the creation of an enduring asset.

COERCIVE
TECHNIQUES

1. Direct Questioning

Verbal questioning of a source. The easiest and often most successful of the non-coercive tactics. Enhancing this approach with suggestive body language lets your source know the new rules of the game without having to state them.

2. Establish Your Identity

Compelling a Middle Eastern source to prove his manliness will trigger an immediate defensive reaction due to his deep cultural investment in personal and family honor.

3. Dietary Manipulation

A classic American breakfast of bacon and eggs served thrice daily will boost the energy of most resistant sources.

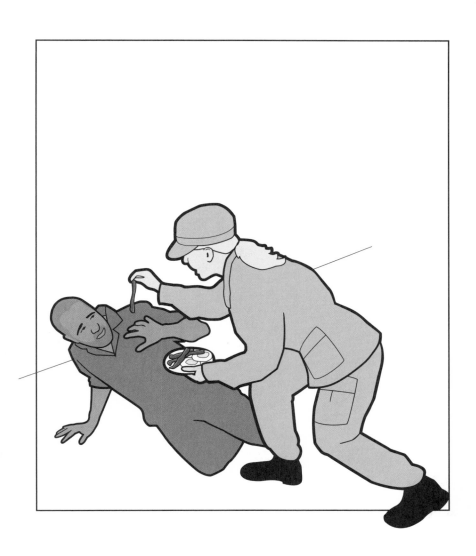

4. Use of Loud Music

Heavy Metal is recommended to elicit a quick response; however, repetitive electronic music played for extended periods has been found to be effective on more resistant sources.

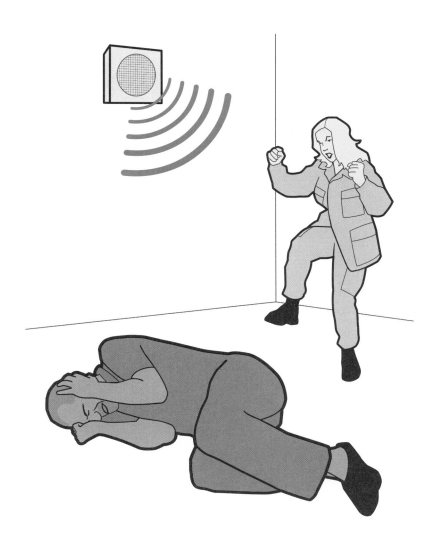

5. Silence

The facial expressions of an interrogator often speak louder than her words.

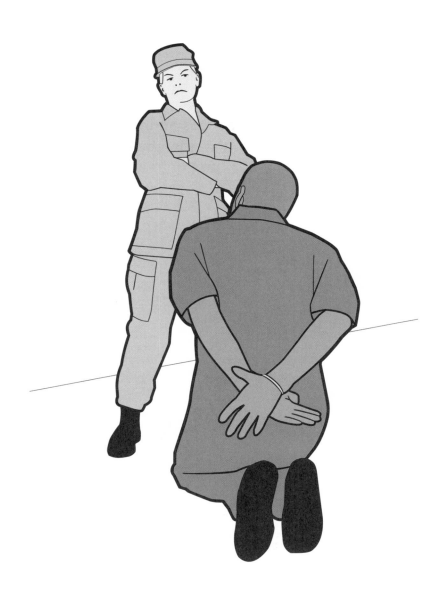

6. Sleep Management

Altering sleep cycles reduces an individual's ability to resist suggestion, thereby expediting coercion and confession.

7. Mutt and Jeff

One of the oldest tricks in the book, but it works like a charm. Basically, he's gotta go for one of you.

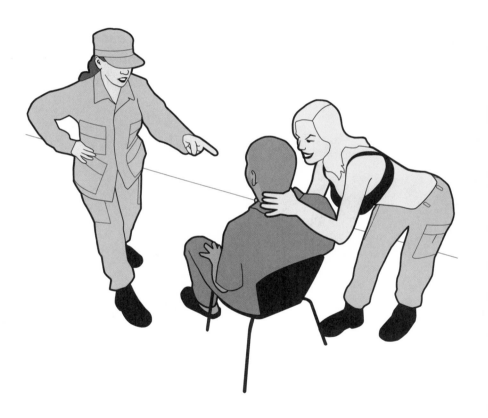

8. Exploiting Cultural Phobias #1

Active stimulation of detainee's fears increases anxiety, often leading to incontinence. The degree of humiliation increases exponentially and heightens regression if performed by a military policewoman in front of other detainees.

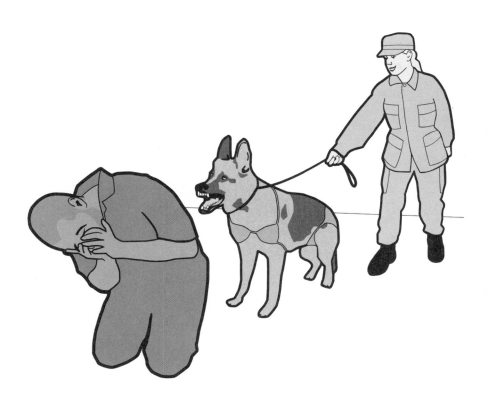

9. We Know All

Sexual degradation is a particularly effective tool for attacking the personalities of devout Muslims because of their taboos concerning homosexuality.

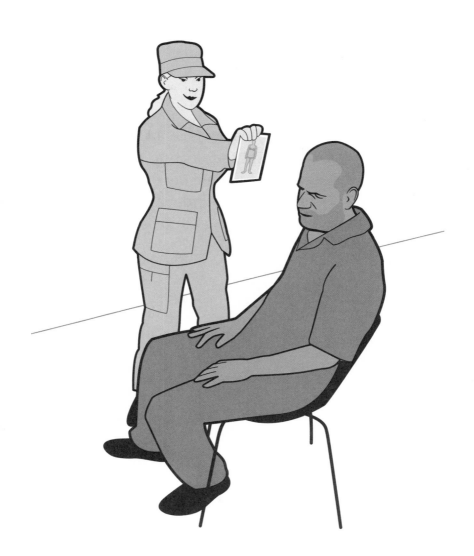

10. Mild Non-Injurous Physical Contact

(i.e., "a little bit of smacky face") Unlike other forms of contact that lead to physical injury, sexual contact is unlikely to leave scars and is more likely to induce guilt that can be taken advantage of by a good interrogator.

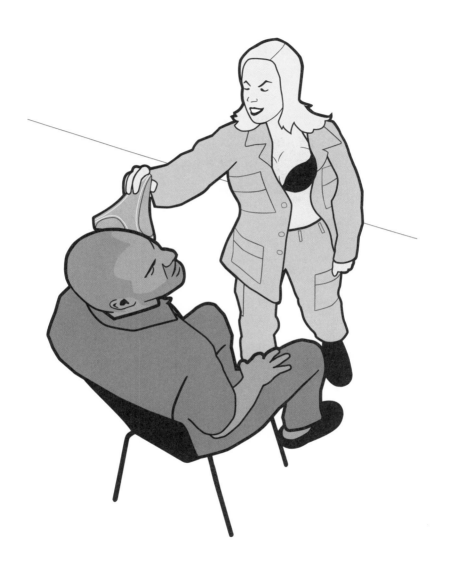

11. Pride and Ego Up

Erotically charged compliments can help to establish a rapport with your source, which eventually can turn to guilt that can be taken advantage of by a good interrogator.

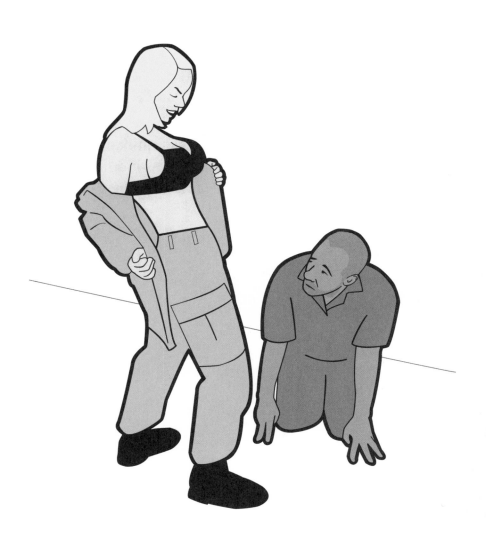

12. Pride and Ego Down

Unlike other forms of contact that lead to physical injury, sexual contact is unlikely to leave scars and is more likely to induce guilt that can be taken advantage of by a good interrogator.

13. Stress Position

Direct sexual advances from a white Christian female generate anxiety in devout Muslim males by forcing them to confront their desire to break cultural taboos.

14. Exploiting of Cultural Phobias #2

Sexually explicit gestures that tamper with religious doctrine are only effective on devoutly religious sources. To prevent others from soliciting them, this tactic should be used sparingly.

15. Fear Up Mild

While most sexually explicit gestures may induce guilt, the ones that violate religious doctrine are most likely to push your source to the crisis point where he will either confess, collapse, or both.

16. Fear Up Harsh

This tactic is so inflammatory that it should be reserved for only the most resistant sources. There is no way to resume a normal exchange after the severe emotional crisis that it is likely to generate.

143

ACKNOWLEDGMENTS

I would like to thank several people and organizations who have supported the research and development of this publication and the artworks that I have created about military interrogation. Dan Turner has contributed his superb talents as an illustrator, and Loid Der has done an amazing job as a graphic designer. The Project in New York, MC Gallery in Los Angeles, and Seven Stories Press have all provided crucial resources and exposure. The teachers at Team Delta enabled me to understand more than I would have ever imagined about the complexities of military interrogation. Finally, I offer my thanks to the military personnel, male and female, active and retired, who were kind enough to share their experiences with me when I was conducting research for my performances and this book.